Great Drawings

from

The Art Institute

of Chicago

BY MARTHA TEDESCHI

INTRODUCTION BY ESTHER SPARKS AND
SUZANNE FOLDS McCULLAGH

HUDSON HILLS PRESS, NEW YORK

AND THE ART INSTITUTE OF CHICAGO

Great Drawings from The Art Institute of Chicago

THE HAROLD JOACHIM YEARS 1958–1983

First Edition
© 1985 by The Art Institute of Chicago

All rights reserved under International and Pan-American Copyright Conventions.
No portion of this book may be reproduced without the permission of the
Publications Department, The Art Institute of Chicago.

Co-published by *The Art Institute of Chicago,* Michigan Avenue at Adams Street,
Chicago, Illinois 60603; and *Hudson Hills Press, Inc.,* Suite 301, 220 Fifth Avenue,
New York, New York 10001.

Distributed in the United States by Viking Penguin Inc.

Distributed in Canada by Irwin Publishing Inc.

Distributed in the United Kingdom, Eire, Europe, Israel, and the Middle East
by Phaidon Press Limited.

Distributed in Japan by Yohan (Western Publications Distribution Agency).

Editor and Publisher, Hudson Hills Press: *Paul Anbinder*

Coordinator of Publications, The Art Institute of Chicago: *Susan F. Rossen*

Editor, The Art Institute of Chicago: *Terry Ann R. Neff*

Copy editor: *Irene Gordon*

Designer: *Betty Binns Graphics*

Composition: *Trufont Typographers*

Manufactured in Japan by *Toppan Printing Company*

Library of Congress Cataloguing in Publication Data

Art Institute of Chicago.
Great drawings from the Art Institute of Chicago.

Includes index.
1. Drawing—Catalogs. 2. Drawing—Illinois—Chicago—
Catalogs. 3. Joachim, Harold, 1909–1983. 4. Art Institute
of Chicago—Catalogs. I. Tedeschi, Martha, 1958–
II. Title.
NC25.C53A762 1985 741.9′074′017311 85-70501

ISBN 0-933920-69-5

All photographs are by Kathleen Culbert-Aguilar, Chicago, except for
catalogue nos. 19, 36, 37, 87, and 88, which are by the Photography Department,
The Art Institute of Chicago.

Contents

List of Colorplates

Foreword

WHEN Harold Joachim passed away in 1983, the loss was felt not only in Chicago, but also throughout the international art community. In recognition of his outstanding achievements as Curator of Prints and Drawings at The Art Institute of Chicago and the personal warmth and charm with which he enriched all who knew him, we are especially pleased to publish this book featuring some of the splendid drawings acquired by the museum during the years of his tenure.

The staff of the Department of Prints and Drawings who worked daily with Dr. Joachim knew him best. In their introduction to this selection, originally compiled by Dr. Joachim, Esther Sparks, Associate Curator in Charge, and Suzanne Folds McCullagh, Assistant Curator, have communicated the intelligence and grace that marked the past quarter-century in the department's history. The author of the catalogue entries, Martha Tedeschi, Research Assistant, has performed an excellent job of writing the commentaries in the spirit Dr. Joachim had intended. Indispensable support has also been provided by various friends, volunteers, and staff members of the department, among them Eva Maria Worthington; Sam Carini, Associate Curator; Gloria Teplitz, Secretary; David Chandler, Conservator; Catherine Maynor, Mellon Fellow in Conservation; and Chris Conniff and Clyde Paton, Preparators.

Finally, I should like to give special thanks to the anonymous donor who steadfastly and unstintingly supported the goals and work of Dr. Joachim and who has provided the funds for this publication, which commemorates his twenty-five years as Curator of Prints and Drawings. This generous gift is indeed a tribute to his memory. This book stands as only a partial record of Harold Joachim's outstanding contribution to The Art Institute of Chicago and to the field itself.

James N. Wood, Director

Great Drawings

from

The Art Institute

of Chicago

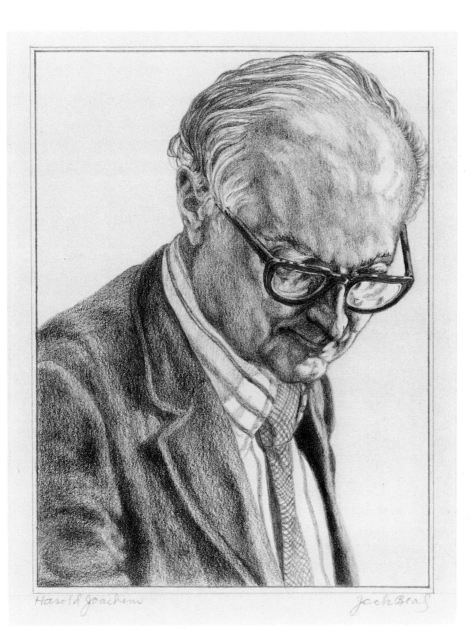

Harold Joachim

Jack Beal

Jack Beal, American (born 1931).
Portrait of Harold Joachim, 1978.
Pencil on paper,
160 x 122 mm (6⁵⁄₁₆ x 4¹³⁄₁₆ in.).
Estate of Harold Joachim (promised gift
to The Art Institute of Chicago).

Introduction

IN the last year of his life, Harold Joachim selected one hundred works for a book on the drawings collection and began to write a preface. We have preserved portions of that text here and have appended commentaries on the drawings. In addition, we have taken the liberty of citing Dr. Joachim's achievements, which, characteristically, he was too modest to do. Joachim's list of one hundred drawings has been increased by three works acquired since his death: a Paul Cézanne watercolor he had always wanted for the collection (cat. no. 73); a Pablo Picasso drawing promised during his curatorship (cat. no. 97); and *Self-Portrait with a Visor* by Jean-Baptiste-Siméon Chardin, purchased in 1984 in part by the Harold Joachim Memorial Fund (cat. no. 34), the mate to a pastel portrait of Madame Chardin which he had added to the collection in 1962 (cat. no. 35).

In his prefatory remarks Joachim had noted:

When it was first suggested to me that I should issue a volume devoted to the most important drawings acquired during my term in office, which began in September 1958, I hesitated at first because the collection of prints and drawings of The Art Institute of Chicago is well over one hundred years old, and many people have contributed to it. But then I thought: What better way is there to express the staff's and my own gratitude to our generous donors and supporters, many of whom are regrettably no longer with us? I have been fortunate to have inherited a department that already had a great momentum in the collecting of drawings, thanks to my predecessor, Carl O. Schniewind, a man who was obsessed with drawings and prints. In the field of drawings, there had been no purchase funds at the museum, but he managed to interest Margaret Day Blake, Mrs. Potter Palmer II, and a few other ladies in donating money for drawings. Mrs. Blake, particularly, became his staunch friend and supporter, and it is my great fortune that she remained loyal to the department even after Mr.

Schniewind's death in 1957. Mrs. Blake had a catholic taste, but she asked of a drawing that it be a strong and characteristic statement of the artist. When I showed her the Pisanello drawing [cat. no. 1], certainly our most important Quattrocento drawing, she knew immediately what it was because, years earlier, Carl Schniewind had taken her to the Cabinet des Dessins in the Musée du Louvre, Paris, where they looked at the great number of Pisanello drawings.

As indicated by Joachim, the strength of the current collection owes much to the insight and cultivation of early donors and trustees. The foundation of the print and drawing collection was laid in 1887 with the bequest of Edward S. Stickney of a collection of 460 prints and a generous fund for acquisitions. Few of the Stickney prints were noteworthy, but the fund enabled the museum's trustees to make the first major acquisition in the field: in 1909 they purchased the Howard Mansfield Collection of prints and drawings by the mid-nineteenth-century French etcher Charles Meryon.

The prints had been maintained in the library up to that point, but after this major coup, a separate print department was founded in 1911 by three important trustees and collectors: Clarence Buckingham, Wallace L. DeWolf, and Kenneth Sawyer Goodman. Mr. Goodman served as the department's first curator until his untimely death at the end of World War I. This early period set the tone for the next thirty years, a time characterized by a concentration on prints rather than drawings, and a collection determined largely by the taste and generosity of the museum's trustees.

Martin A. Ryerson, perhaps the most generous donor of art works of all periods to the Art Institute, played a significant role in establishing French art as a main strength of the department: in 1920 he directed the use of the Stickney Fund to purchase the entire graphic oeuvre left by the Symbolist artist Odilon Redon to his widow. In 1932 he established the American collection with the donation of a complete set of Mary Cassatt's glorious *Ten Etchings in Color*. This formative period was crowned by the acquisition in 1938 of the Clarence Buckingham Collection, a bequest of his sister, Kate S. Buckingham, of the greatest group of old master prints to come to the museum. "This group," Joachim observed,

added to the Art Institute a much-needed collection of prints by Dürer, Rembrandt, van Dyck, and many others. Furthermore, part of this gift was a purchase fund and this fund, wisely administered, has been a blessing for the department ever since. Through the Buckingham Fund, Mr. Schniewind was able to acquire some of the greatest Rembrandts, drawings as well as etchings, and was able to assemble an absolutely unique collection of Gauguin woodcuts.

The drawing collection initially lagged behind the print collection, in quality if not in quantity. In 1922 William Frank Eugene Gurley, a geologist and paleontologist at the University of Chicago, gave the museum a group of over 6,000 old master drawings in memory of his mother, Leonora Hall Gurley. Consisting largely of worn sheets by unidentified seventeenth-century masters, this collection had been formed by purchasing lots from London firms after European connoisseurs had rejected them because of uncertain or inflated attributions. It has taken several generations of art historians to reassess the value of the group—a process that continues to this day.

Professor Gurley's collection was weakest in the French school, but in the same year, smaller but prophetic gifts of drawings by acknowledged French masters of the nineteenth and twentieth centuries, such as Eugène Delacroix, Edgar Degas, Paul Gauguin, Henri Matisse, and the Spaniard Pablo Picasso, came from Robert Allerton and Emily Crane Chadbourne. In 1927 the Art Institute received another 5,500 prints and drawings through Charles Deering's collection, but, as in the case of the Gurley contribution, these, too, have required many years of scholarly assessment.

In 1940, with the appointment of Carl O. Schniewind (1900–1957) as curator, the Art Institute gained an expert in French drawings. Schniewind called a halt to publication plans for the drawings, insisting that before there could be a catalogue of the collection, there had to be a collection worthy of publication. He undertook the task of building one immediately, and his remarkable success is evident in an exhibition and catalogue of 1946. *Drawings Old and New* included fifty-five drawings, forty-three of which were acquired in the preceding six years. It was, above all, in the area of French nineteenth-century drawings that Schniewind excelled, and he matched the strengths of the Art Institute's painting and print collections by adding major sheets and sketchbooks of artists ranging from Théodore Géricault to Henri de Toulouse-Lautrec.

Perhaps among Schniewind's most astute contributions to the collection was his appointment in 1946 of Harold Joachim, then thirty-seven years old, as Assistant Curator of Prints and Drawings. A refugee from Nazi Germany, Joachim had been born in Göttingen into a family of musicians and intellectuals—Brahms's Violin Concerto, written in 1878, was dedicated to his grandfather, the famed violinist Joseph Joachim. Joachim himself was a passionate music lover, and for more than thirty years he played the viola in chamber music sessions with both amateur and professional musicians.

Joachim arrived in the United States in 1938 with a doctorate in

Romanesque architecture from the University of Leipzig. When still a young man, however, he had studied prints and drawings under his uncle C. G. Boerner, in whose auction house in Leipzig during the 1930s one could see great treasures of prints and drawings flushed from important European collections by the Depression. In the United States Joachim served from 1938 to 1940 as an assistant in the Print Room of the Fogg Art Museum, Cambridge, Massachusetts, under Jakob Rosenberg, and in 1940 and 1941 he worked in the Harvard University Library under Philip C. Hofer. During his years at Harvard, the shy and somewhat retiring scholar participated in Paul J. Sachs's museum seminar, where he formed lasting friendships with men and women who would also become prominent curators and art historians. In March 1941 Joachim committed himself to his new country by enlisting as a private in the United States Army. Amid the horrors of night watches in New Guinea, he maintained his sanity by rehearsing Mozart quartets in his mind. Though he spoke of those years with the utmost reluctance, he did admit to having won a Silver Star for bravery.

Throughout the ten years of his apprenticeship under Carl Schniewind, Joachim quietly accomplished a great deal for the Art Institute, cataloguing the collection, training his eye, and maintaining the Print Room during Schniewind's frequent trips. In 1956 Joachim was invited by The Minneapolis Institute of Arts to become Curator of Prints and Drawings. In the brief span of two years he made acquisitions and produced exhibitions for which that institution is still renowned. When Carl Schniewind died in 1957, Joachim was called back from Minneapolis to fill the position of Curator of Prints and Drawings at Chicago. With a prescience that is touching in retrospect, he put aside his viola when he returned to Chicago in 1958. His devotion to his task and the quality of his achievements brought him attractive offers until the end of his career, but he remained faithful to the collection in Chicago and believed wholeheartedly in its value for future generations.

Often called the "Dean of Print Curators," Joachim made astonishing acquisitions of old master and modern prints, ranging from his first major purchase, *The Road to Calvary* by the fifteenth-century Master of the Amsterdam Cabinet, to his last and largest coup, the complete editions and archives of the Universal Limited Art Editions workshop established on Long Island in 1957 by Tatyana Grosman. But perhaps nothing gave him greater satisfaction or pride than his additions to the drawing collection. From time to time, and only for a moment, Joachim would set aside his habitual modesty and admit that the collection had grown in an unprecedented way

under his care. His accomplishments are evident throughout this book.

In his first year as curator, Joachim made a notable acquisition in memory of Carl Schniewind: Giovanni Battista Tiepolo's early ink and wash composition *The Meeting of Abraham and Melchizedek* (cat. no. 17), a work for which Schniewind had been denied purchase approval. Under a new administration, Joachim called the work back and thereby brought one of the earliest and most formidable images of eighteenth-century Venetian art to the Midwest. In that same year, thanks to Helen Regenstein, he acquired the collection's first drawing by Francisco de Goya, the provocative *Be Careful with That Step!* (cat. no. 50). These two masterpieces announced Joachim's policy: to build on his predecessor's strength and to bring new and important masters into the collection.

Just as Carl Schniewind had celebrated his early acquisitions with an exhibition and catalogue, so, too, did Harold Joachim mark his first contributions to the drawing collection with an exhibition and catalogue. Nearly half of the works shown in the exhibition held at Wildenstein's in New York in 1963, *Master Drawings from the Art Institute of Chicago*, had been acquired in just five years. The prospect of showing the "Second City's" treasures in New York may even have accelerated some purchases. No fewer than seven old master drawings included in this exhibition were acquired in the year preceding the Wildenstein presentation. Significant additions to the collection included the Art Institute's first two drawings by Goya (cat. nos. 50, 51), its first two sheets by Giovanni Battista Piranesi (cat. nos. 24, 25), and its first examples of Francois Boucher's draftsmanship (cat. nos. 38, 39). Of particular rarity were a superb Rembrandt landscape drawing (cat. no. 31), the double-sided sheet by Pisanello (cat. no. 1), two large compositions by Alessandro Magnasco (cat. nos. 9, 10), and Chardin's pastel portrait of his wife (cat. no. 35). Proceeds from catalogue sales benefited the department's research fund.

Schniewind's staunch ally and supporter, Margaret Day Blake, remained loyal to the department. Among Joachim's favorite recollections were two Sunday afternoons during her last years, a time when he would visit regularly at her bedside:

Another incident that I remember well was when I brought her one of our great Picasso drawings, *The Embrace of the Minotaur* [cat. no. 96]. At that time, she was no longer going out, but I took to her every important drawing that I wanted to acquire for the museum. She looked at me and said, "What a

pity, but my accountant has just told me that I cannot spend any more money for drawings, so you will just have to find another source." On the following Sunday she asked me, "How did it go with the Picasso?" and I answered, "Not well; a very influential member of the committee has questioned the suitability of the subject for a public museum." Mrs. Blake said immediately, "In that case, I will have to give it—they wouldn't dare reject it if it comes from me."

Mrs. Blake died in 1971 at the age of ninety-six. Shortly before her death the department arranged an exhibition of all her gifts. She came to the museum for the last time, in her wheelchair. The exhibition showed an amazing range of taste and a remarkable understanding of the many phases of draftsmanship.

Mrs. Blake shared with Carl Schniewind a passion for the drawings of Antoine Watteau and Jean-Honoré Fragonard but, oddly enough, neither she nor he was interested in the work of Boucher, which should be included in any representative collection of French drawings. This lacuna would be filled by Helen Regenstein, who became interested in the drawings department in 1957. She made it her task to buy significant eighteenth- and nineteenth-century French drawings, as well as eighteenth-century Italian drawings. What she accomplished in these fields can never be sufficiently appreciated. Before Mrs. Regenstein's time, there was no work by Giovanni Battista Piazzetta, no major example of Tiepolo, none of Francesco Guardi or Magnasco in the collection. Drawings by these artists and others that she bought for the Art Institute raised that part of the collection to the level of the Institute's fine collection of eighteenth-century paintings. Mrs. Regenstein stepped out of her favorite domain only a few times, in order to aid in the acquisition of twentieth-century drawings when the entire Advisory Committee got together for such important purchases as the large colored drawings by Arshile Gorky, Jackson Pollock, and, more recently, Joan Miró (cat. nos. 101, 102, 98). Even though she did not really like these drawings, she felt that the Art Institute should have them.

During the 1960s a number of important works were bought by the department either directly or indirectly from major auction sales: in 1961 Fragonard's *Bull of the Roman Campagna* (cat. no. 41) was procured from the Princess Murat (née Vanderbilt) sale, and Paolo Veronese's *Head of a Woman* (cat. no. 3) from the Springell sale; in 1964 Mrs. Regenstein obtained the great Watteau drawing *The Old Savoyard* (cat. no. 36) at the Kavanagh sale. (Joachim warmly recalled the pact he had made with Jacob Bean, Curator of Drawings at The Metropolitan Museum of Art, at the Kavanagh sale: the Art Institute did not bid against the Metropolitan for the *Madonna and Child with*

the Infant Saint John by Raphael, and Jacob Bean stepped aside so that the Art Institute might get Watteau's *Old Savoyard*. Joachim recognized both the strengths and the necessary limits of the collection.) In 1965 Mrs. Blake arranged for the London dealer Hans Calmann to buy for her the large Pietro da Cortona sheet (cat. no. 6) from the Harewood sale, and the Buckingham Fund enabled the purchase from Sir Kenneth Clark of the major composition by Giovanni Benedetto Castiglione (cat. no. 7). But these purchases were the exception rather than the rule; most works continued to come to the collection from American dealers who specialized in fine drawings.

At the same time that Mrs. Blake and Mrs. Regenstein were primary forces in molding the distinctive profile of the Art Institute's drawing collection to Joachim's design, other funds and donors enabled him to make important additions in other fields. With the Clarence Buckingham Fund, he brought the first drawing by Albrecht Dürer into the collection (cat. no. 26), as well as the Hendrik Avercamp watercolor (cat. no. 28) and a portrait by Henry Fuseli (cat. no. 52), in order to strengthen the representation of the Northern schools.

There were just three chairmen of the Advisory Committee during Joachim's curatorship, each of whom applied himself with unselfish and wholehearted devotion. The first, Frank B. Hubachek, was a dedicated print collector who gave the Art Institute most of its important works by Jacques Villon and an important Surrealist drawing by Salvador Dali (cat. no. 99). He was succeeded by Sigmund Kunstadter, who had a special interest in Paul Klee and Lyonel Feininger, and who was instrumental in securing for the museum the Frank and Ursula Laurens Collection of Klee graphics, which contained some very rare and unique items. He also enabled Joachim to bring Ernst Ludwig Kirchner's monumental *Two Nudes* (cat. no. 85) into the collection. Edwin A. Bergman, the current chairman, has contributed many distinguished twentieth-century works and has been a significant factor in the two costliest single purchases of twentieth-century graphics in the museum's history: Miró's *Kerosene Lamp* (cat. no. 98) of 1925, in honor of Joachim's twentieth year as curator, and, more recently, the Universal Limited Art Editions prints and archives.

Major gifts of drawings and funds from members of the Advisory Committee further helped to build the nineteenth- and twentieth-century collections. In 1965 Leigh B. Block, then chairman of the board of the Art Institute, contributed the haunting drawing by Domenico Quaglio (cat. no. 54). Mr. and Mrs. Stanley M. Freehling

have given major examples of German Expressionism by Kirchner, Max Beckmann, and George Grosz (cat. nos. 86, 88, 89). Picasso's *Head of a Woman* (cat. no. 94) came from Mr. and Mrs. Roy J. Friedman. Egon Schiele's *Russian Prisoner of War* (cat. no. 92) was the gift of Dr. Eugene A. Solow. The funds for the important sheet by Theo van Doesburg (cat. no. 93) were provided by Miss Margaret Fisher. The acquisition of superb works by Gorky and Pollock (cat. nos. 101, 102) was made possible with funds from Peter Bensinger, Mrs. Leigh B. Block, Margaret Fisher, William Hartmann, Helen Regenstein, and Joseph R. Shapiro, among others.

The 1970s was a decade less notable for active buying than for the thoughtful renovation of the department facilities, with funds provided by Helen Regenstein, and for the exhibition and publication of the Blake and Regenstein collections, in 1971 and 1974 respectively. No doubt the healthy spirit of competition between Mrs. Blake and Mrs. Regenstein worked to the collection's advantage. Indeed, the commitment they shared to building the collection is reflected in Margaret Day Blake's last major purchase, Tiepolo's *Three Angels Appearing before Abraham* (cat. no. 18), which embellished the group of drawings Mrs. Regenstein had formed. The endowed fund left by Mrs. Blake to continue her collection of drawings enabled Joachim to add the spiritual landscape by Caspar David Friedrich (cat. no. 53), among other works.

Mrs. Regenstein's acquisitions in the 1970s were somewhat less numerous than in the previous decade, but no less spectacular, with the unparalleled coup of the nine studies of heads by Piazzetta from the Schulenburg Collection (cat. nos. 12–14) in 1971, a stirring Jacques-Louis David portrait (cat. no. 46) in 1973, Watteau's rare compositional study for the *Feast of Love* (cat. no. 37) in 1975, and the breathtaking *Panorama from the Sasso* (cat. no. 33) by Claude Lorrain in 1980—the last drawing she bought before her death. The department is fortunate that Helen Regenstein's commitment to the collection is carried on by her son, Joseph Regenstein, Jr., and daughter, Mrs. Robert Hartman, who, since 1980, have added magnificent pieces to the collection, such as Delacroix's *Peasant Women of the Eaux-Bonnes* (cat. no. 59) and two very dissimilar drawings by Gustave Moreau (cat. nos. 64, 65).

Younger donors who came to the fore at the end of Joachim's career made possible the purchase of striking portraits by Käthe Kollwitz, Paula Modersohn-Becker, and Oskar Kokoschka (cat. nos. 80, 81, 91). Other major gifts reinforced the strength of the department's eighteenth-century holdings with works by Fragonard, Hubert Robert, and Gabriel de Saint-Aubin (cat. nos. 42, 43, 44).

Highly coveted watercolors by Paul Gauguin and Cézanne (cat. nos. 72, 73) were recent gifts. Perhaps the greatest pleasure Joachim knew in his last year, apart from the thought he gave to this book, came from the superb composition by Federico Barocci (cat. no. 4), which he acquired by means of generous funds from the same anonymous donor who supported this volume.

It is indeed appropriate that this work be dedicated not only to Dr. Harold Joachim, whose memory remains alive in these drawings, but also to the inspired and generous donors who shared his love of quality.

Esther Sparks, Associate Curator in Charge
Suzanne Folds McCullagh, Assistant Curator
August 1984

Great Drawings

from

The Art Institute

of Chicago

Pisanello (Antonio Pisano)

Italian, c. 1395–c. 1455

*Studies of the Emperor John VIII
Palaeologus, a Monk, and a Scabbard* (recto)
Bow Case and Quiver of Arrows (verso)
1438

Pen and brown ink on ivory laid paper
190 × 266 mm (7½ × 10½ in.)
Inscribed recto, center, in pen and brown ink: *chaloire*(?)
Margaret Day Blake Collection, 1961.331

PISANELLO is considered to be the most important representative of the brilliant but brief International Gothic style that flourished primarily in France, England, and Italy in the late fourteenth and early fifteenth centuries. This transitional style marked the end of tight medieval craftsmanship and the dawning of the Renaissance exploration of the natural world. Pisanello's drawings—which are exceedingly rare, particularly in this country— reflect this remarkable cultural change even more than his paintings.

In 1438 John VIII Palaeologus, emperor of Byzantium, which by the time of his reign (1425–48) had been reduced by the Turks to the city of Constantinople, went to Ferrara for the convening of the Council of Ferrara-Florence. To commemorate the event, Pisanello made a medallion showing the emperor in profile on one side, and on horseback on the other. The Art Institute's drawing and a similar sheet in the Musée du Louvre, Paris, are the earliest known preparatory studies for the medallion. The figure studies on the recto of the sheet are all of the emperor, with the possible exception of the cloaked man seen from the back, who has been identified tentatively as a monk. During his visit, the emperor is said to have spent much of his time riding and hunting in the environs of Ferrara; appropriately, Pisanello has depicted him mounted, in full hunting attire. His scabbard is delineated in detail at the top of the drawing. The verso bears a study of his bow case and quiver. These precise investigations of the emperor's regalia recall the elegance of Gothic tracery, while the freer hatching and modeling of the figures reveal the growing interest in naturalism.

24

RECTO

VERSO

CATALOGUE NO. 1

Giorgio Giulio Clovio

Italian/Croatian, 1498–1578

*The Four Evangelists within a Border
of Flowers, Birds, and Insects*
c. 1572

Tempera and gold paint on vellum
367 × 250 mm (14⅞ × 9⅞ in.)
Bequest of Katherine R. Loewenthal, 1982.438

PRAISED during his lifetime as the "Raphael of Miniature,"
Giulio Clovio is regarded as the most important Italian
miniaturist of the sixteenth century. This luminous sheet is unusual
in that it is a composite of assembled fragments. The four seated
Evangelists seem to date from the middle of the artist's career, before
his style adopted the attenuated forms of Mannerism. The decorative
border, in which birds, flowers, and insects are rendered with
scientific exactitude and the Virtues and Vices are depicted in three
cartouches, bears the coat of arms of Pope Gregory XIII. Since
Gregory became pope in 1572, this portion of the composition must
be dated to the last years of Clovio's life. It is likely that the miniature
originally was part of a lectionary belonging to the pope.

During the Napoleonic period, French commissaries plundered the
treasures of the papal collections, and at least sixty manuscripts were
stolen from the Sistine Chapel. Many of them are known to have
been cut up and reassembled; this clearly seems to have been the
history of this sheet. In spite of its turbulent past, the miniature
retains the freshness and delicacy of Clovio's jewellike palette.

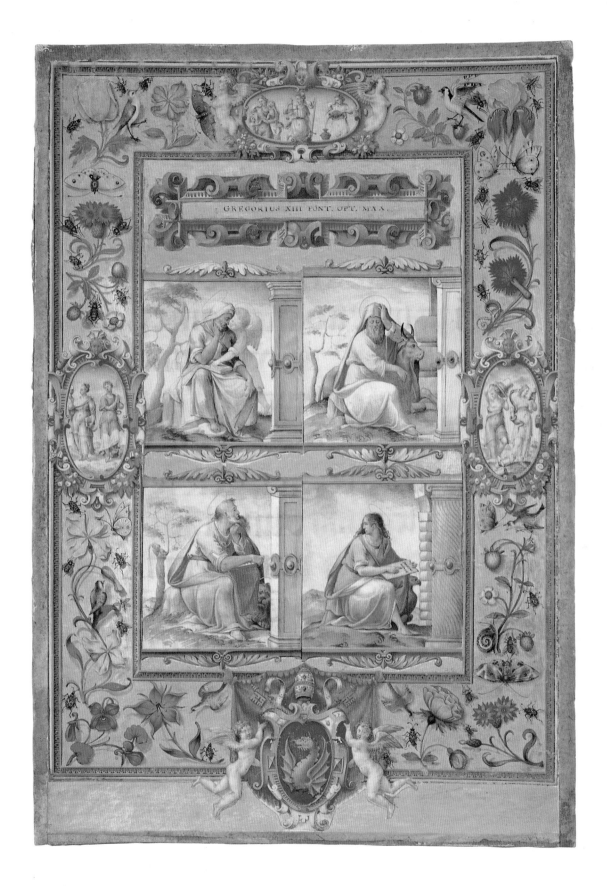

CATALOGUE NO. 2

Veronese (Paolo Caliari)

Italian, c. 1528–1588

Head of a Woman

c. 1575(?)

Black and white chalk on bluish-gray laid paper

266 × 187 mm (10½ × 7⁷⁄₁₆ in.)

Margaret Day Blake Collection, 1962.809

ONE of the great painters of the second half of the sixteenth century, Veronese was a favorite artist of the Venetian court. A generation younger than Titian, whom he succeeded as master of the Venetian school, Veronese is famous for his coloristic achievements in painting. He was also a brilliant and versatile draftsman whose works on paper, even when executed in black and white, reveal a painterly sensibility. Although he employed a wide range of techniques, chalk studies of individual figures, such as this sensitive portrait of a woman, are rare. The same female facial type—fair, with soft, full features and rounded contours—occurs in many paintings by Veronese and his followers. The Art Institute's drawing has been associated with the painting *Pomona* in the Czartoryski Gallery, Kraków.

28

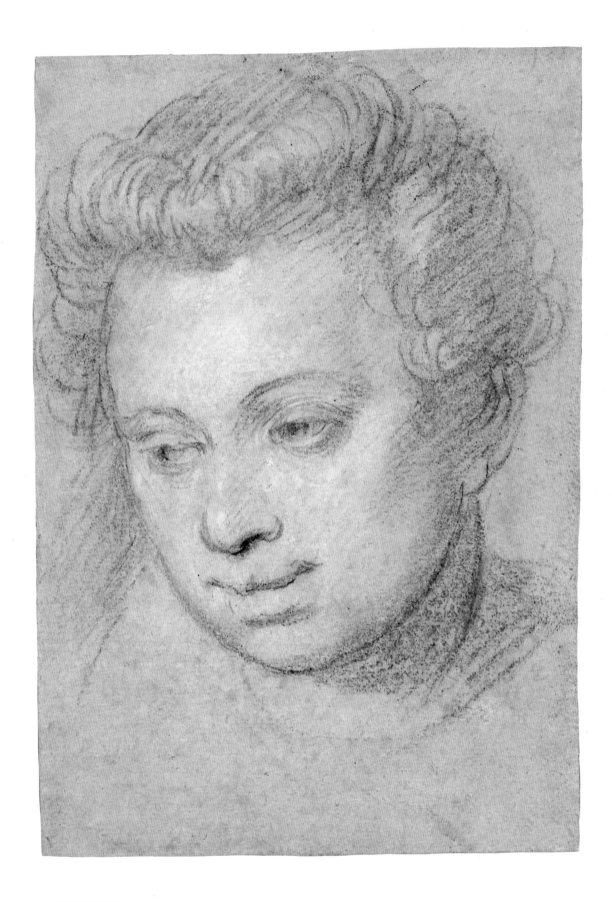

CATALOGUE NO. 3

Federico Barocci

Italian, 1535–1612

The Entombment of Christ

Early 1580s

Pen and brown ink with brush and brown wash over black chalk, squared in red chalk, on ivory laid paper

485 × 342 mm (19⅛ × 13½ in.)

Anonymous gift, 1983.8

W ITH the exception of a brief but valuable stay in Rome in the mid-1550s, Federico Barocci—after Raphael, the most important painter of Urbino—spent his entire career in his native city. His extraordinary powers as a draftsman can be seen in this majestic study for *The Entombment of Christ*, which he painted in the early 1580s for the church of Santa Croce in Senigallia. *The Entombment* demonstrates Barocci's classical style, a synthesis of the solidity and idealized line of Raphael with the Venetian colorism and composition of Titian. A number of drawings documenting the artist's development of the painting have survived; this pen and ink *modello*, or compositional presentation drawing, delineates the total composition, squared in red chalk for enlargement and transfer. The superimposed grid reveals the highly sophisticated geometric construction Barocci devised for a major figurative composition. The energetic and precise draftsmanship is extremely moving and expressive; the vibrant, electric quality of the lines may relate to Barocci's concurrent experimentation with printmaking.

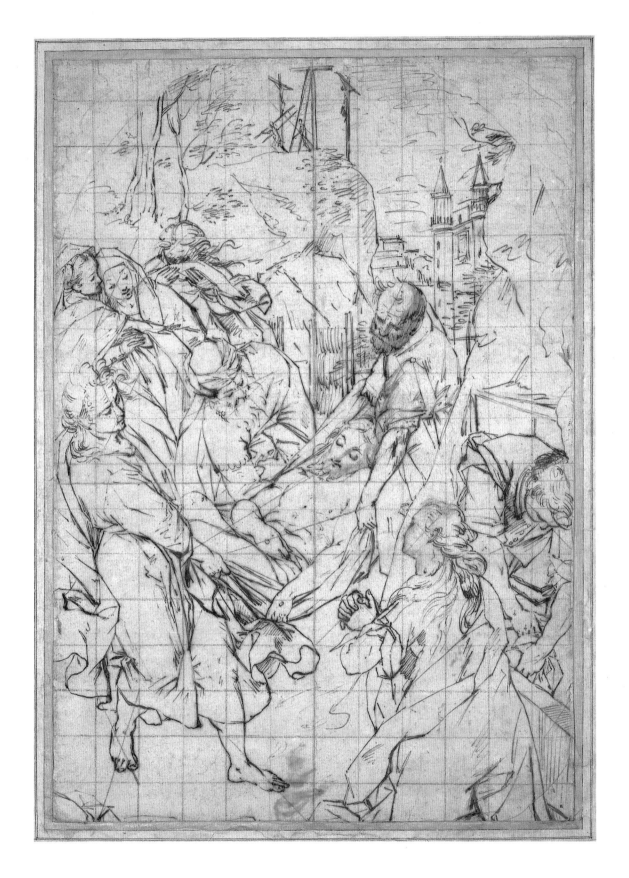

CATALOGUE NO. 4

Palma Giovane (Jacopo Negretti)

Italian, 1544–1628

The Entombment of Christ

c. 1590/95

Pen and brown ink with brush and brown wash, heightened with gold, on bluish-green laid paper

223 × 140 mm (8¹³⁄₁₆ × 5½ in.)

Clarence Buckingham Collection, 1962.376

DESPITE a three-year period of study in Rome, Palma Giovane's style was thoroughly grounded in the work of the great Venetian masters Titian, Tintoretto, and Veronese. Palma was one of the most prolific draftsmen of his generation; his descriptive naturalism resembles that of the Bolognese painter Annibale Carracci and, as was the case with this *Entombment of Christ*, their drawings occasionally have been confused. The correct attribution to Palma was first made by the collector Frits Lugt, who owned another Palma drawing with gold heightening. In a Palma painting in Zagreb, tentatively dated to the early 1590s, there are three holy women in the foreground who resemble those in the Art Institute's drawing.

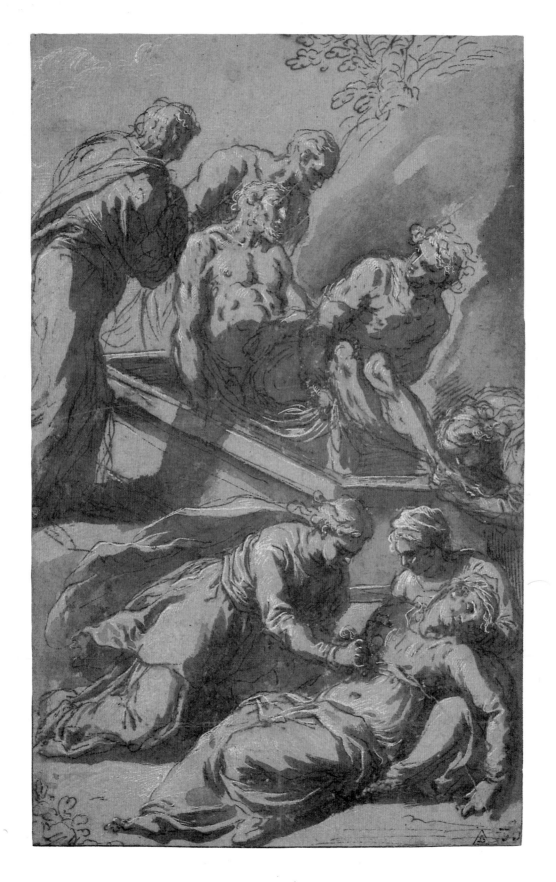

CATALOGUE NO. 5

Pietro da Cortona (Pietro Berrettini)

Italian, 1596–1669

The Holy Trinity with Saint Michael Conquering the Dragon
c. 1668

Pen and brown ink with brush and brown and gray wash, heightened
with white gouache, over traces of black chalk, on buff laid paper

458 × 360 mm (18¹⁄₁₆ × 14³⁄₁₆ in.)

Margaret Day Blake Collection, 1965.860

BORN in Cortona and first trained by a Florentine teacher, Pietro
da Cortona at the age of sixteen or seventeen arrived in Rome,
where he spent most of his illustrious career. A contemporary of
Gianlorenzo Bernini and Francesco Borromini, Pietro was an architect
as well as a painter and decorator. This exuberant drawing, similar to
his splendid High Baroque ceiling frescoes in its rich play of dazzling
light and active, monumental forms, demonstrates his virtuosity in
the broad handling of brush and wash. The sheet, characteristic of
the artist's last years, is probably a *modello* for *Saint Michael Slaying the
Dragon*, a painting once in the Vatican but now lost.

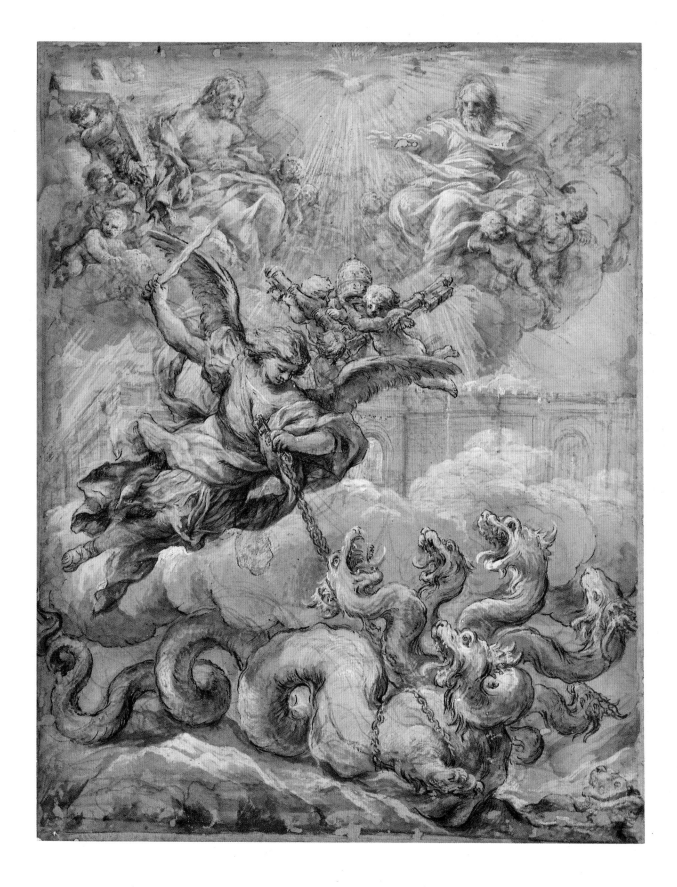

CATALOGUE NO. 6

Giovanni Benedetto Castiglione

Italian, c. 1610–1665

A Pagan Sacrifice

Late 1640s

Brush with oil paint on tan laid paper; laid down

576 × 425 mm (22¾ × 16¹³/₁₆ in.)

Clarence Buckingham Collection, 1968.77

THIS highly finished drawing—essentially a small painting with brush and oil pigment on paper—is a superb example of Castiglione's mature style. The scene is the sacrifice of an ox to an unidentified pagan deity, sketched in lightly at the right. At one time this drawing probably had a pendant with a Christian subject, perhaps Tobit Burying the Dead. Such an enigmatic parallel between pagan and Christian sacrifice would have appealed to the select, erudite Roman audience for whom Castiglione's presentation drawings were intended. The carefully constructed classical composition, as well as the handling of the brush, is characteristic of Castiglione's oil drawings of the late 1640s and suggests the infusion of monumental Roman qualities into his native Genoese style. During his extended stay in Rome (c. 1634–50), Castiglione was greatly influenced by Nicolas Poussin and Peter Paul Rubens and applied some of the grandeur and vigor of their styles to his own mystical fervor.

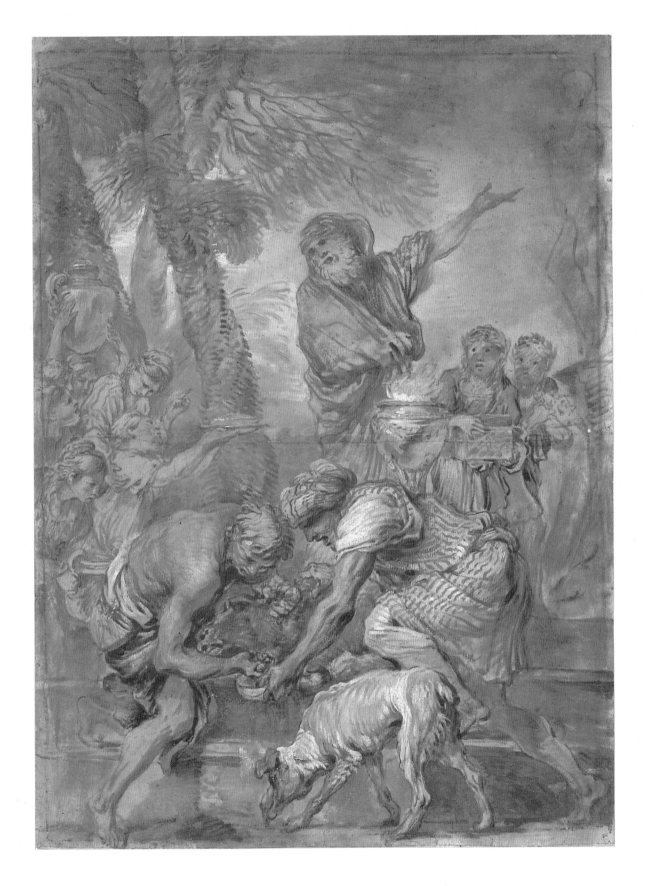

CATALOGUE NO. 7

Guercino (Giovanni Francesco Barbieri)

Italian, 1591–1666

The Martyrdom of Saint Bartholomew

c. 1635

Pen and iron gall ink with brush and brown wash on ivory laid paper
297 × 205 mm (11¾ × 8⅛ in.)
Gift of Mr. and Mrs. Norman Pritchard, 1960.832

GUERCINO's painterly wash drawings, frequently stronger than his finished oils, were very influential in spreading his style throughout Europe. Their rich, Caravaggesque chiaroscuro brought an element of drama to mid-seventeenth-century Bolognese drawing, which is clearly exemplified by this powerful preparatory study for *The Martyrdom of Saint Bartholomew* in the church of San Martino in Siena, painted by Guercino between January 1635 and April 1637. There exist two other drawings for the San Martino commission, one in The Art Museum, Princeton University, and the other in the Pierpont Morgan Library, New York. In the Art Institute's drawing, Guercino's fine, agitated pen contours combine with forceful strokes in brown wash to create a dynamic, nervous play of light over the muscular figure of Saint Bartholomew, who is about to be flayed alive with a butcher's knife.

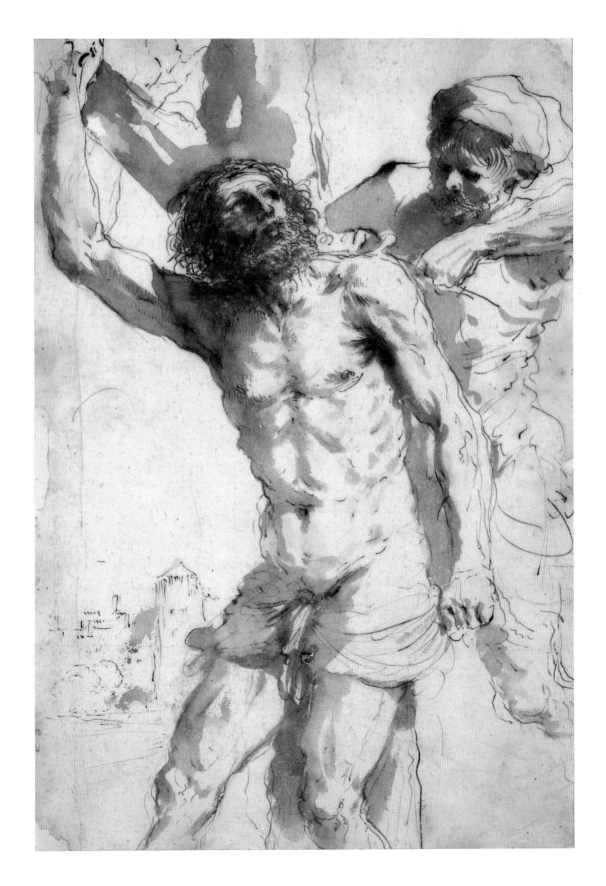

CATALOGUE NO. 8

Alessandro Magnasco

Italian, 1667–1749

Picaresque Group with a Monkey and Magpie
1720/25

Brush with reddish-brown chalk wash, heightened with
white chalk wash, over black chalk, on faded blue laid
paper
478 × 372 mm (18⅞ × 14¹³⁄₁₆ in.)
Helen Regenstein Collection, 1962.586

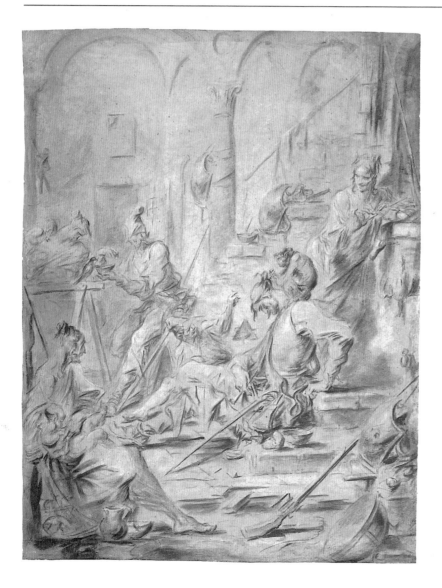

A Genoese artist who worked mostly in Milan, Alessandro Magnasco led a Bohemian existence that provided him with the characters who populate his work: vagabonds, gypsies, balladeers, artists, and soldiers. Rarely did his unique style find such forceful expression as in this fine pair of drawings. The vibrant, flickering brushwork in reddish-brown and white chalk washes is similar to the agitated strokes of heavily applied impasto in his paintings.

Picaresque Group with a Monkey and Magpie features the centrally placed seated figure of a soldier who is being "groomed" by a monkey. The magpie and the monkey both are recurrent motifs in Magnasco's imagery, as is the haggard old woman with a baby at the left. The cavernous-cellar setting may be based on Magnasco's own studio. It is possible that this enigmatic scene was intended as a parody of the cowardly soldier, who prefers a life of laziness to deeds of valor.

Ballad Singer at a Shrine of the Virgin
1720/25

Brush with reddish-brown chalk wash, heightened with white chalk, over black chalk, on faded blue laid paper

467 × 370 mm (18⅝ × 14⅝ in.)

Helen Regenstein Collection, 1962.585

In *Ballad Singer at a Shrine of the Virgin*, Magnasco treated another favorite theme. Clearly the sheet was intended as a companion piece to the *Picaresque Group*, although it is not known whether the two were planned as a pair or whether both belonged to a larger set. Whatever the case, they are finished works of art and not necessarily studies for paintings. In both drawings we see Magnasco's draftsmanship at its freest and most confident.

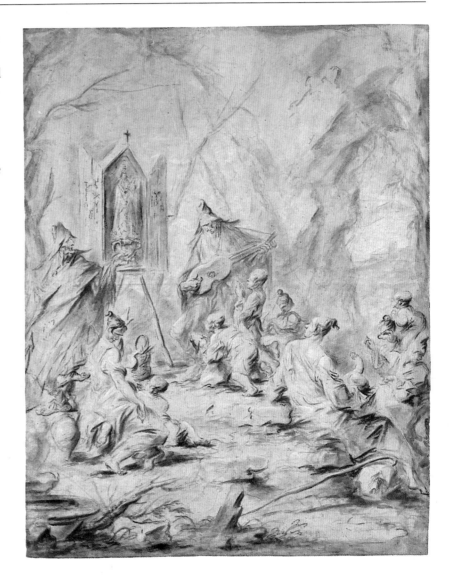

Donato Creti

Italian, 1671–1749

The Astronomers

1711

Pen and brown ink with brush and brown wash on ivory laid paper

242 × 325 mm (9⁹⁄₁₆ × 12⅞ in.)

Worcester Sketch Fund, 1962.791

IN 1711 Donato Creti, one of the leading painters of Bologna, received a commission from Count Luigi Marsiglio to create a series of eight paintings (now in the Vatican) based on the five known planets, the sun, the moon, and a comet. *The Astronomers* is a study for the canvas representing the scientific observation of Mars; the drawn figures are almost identical to the group of men depicted in the painting. The astronomical apparatus so carefully rendered in the drawing is less prominent in the final work, where Creti pursued instead his inclination toward a more lyrical vision of landscape. Yet, despite the dominance of its scientific theme, the sheet is lyrical as well, exhibiting the gentle, silvery quality that is characteristic of Creti's finest drawings.

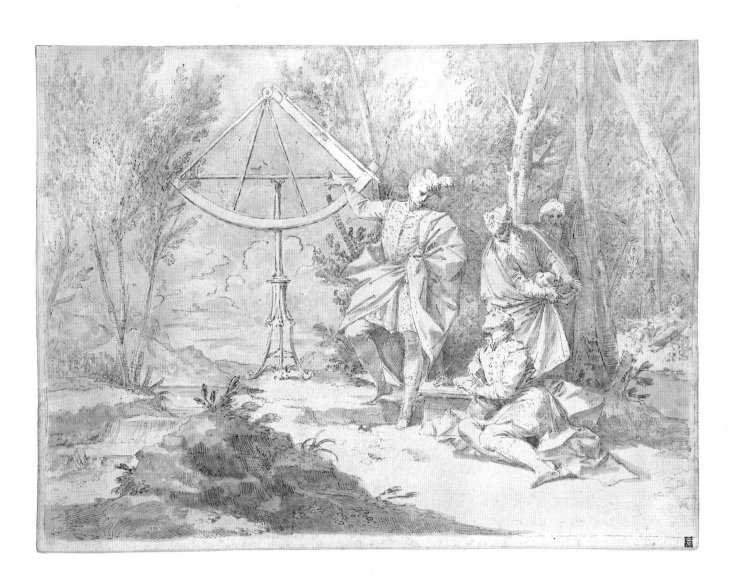

CATALOGUE NO. 11

Giovanni Battista Piazzetta

Italian, 1682–1754

Portrait of the Field Marshal Count von der Schulenburg
1731

Black and white chalk with *estompe* on buff laid paper; laid down
501 × 382 mm (19¹³⁄₁₆ × 15⅛ in.)
Helen Regenstein Collection, 1971.325

COUNT Matthias von der Schulenburg (1661–1747) was called out of retirement in Germany by the Venetian senate in 1715 to defend the republic against the threat of Turkish invasion. Following the defeat of the Turks at Corfu, he settled in Venice, where he began to collect the works of numerous Venetian artists, commissioning Canaletto, Francesco Guardi, Giovanni Battista Pittoni, and others. His first contact with Giovanni Battista Piazzetta, a gifted exponent of the Venetian Baroque who specialized in portraits and head studies, seems to have been in 1731. In the course of the fruitful alliance that followed, the count collected no fewer than thirteen of Piazzetta's paintings and nineteen of his drawings. A set of nine very fine drawings from this important collection entered the Art Institute in 1971, among them this candid and penetrating portrait of the field marshal himself. One of three known portraits that Piazzetta made of him, this study of the count at age seventy reveals an intelligent, sophisticated, and discriminating man.

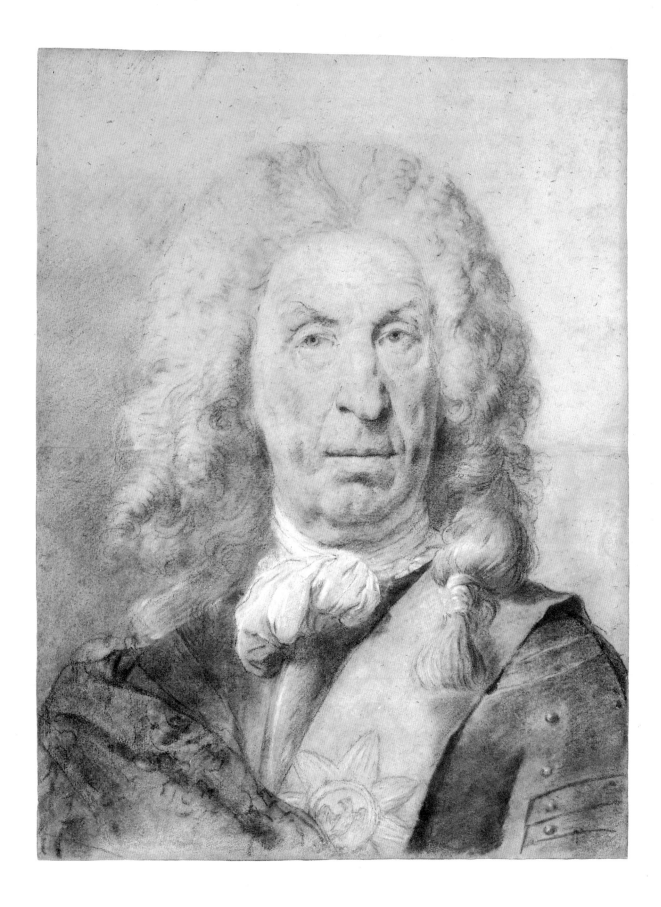

CATALOGUE NO. 12

Giovanni Battista Piazzetta

Boy Feeding a Dog
1738/39

Black and white chalk with *estompe* on gray laid paper; laid down
534 × 432 mm (21⅛ × 17⅟₁₆ in.)
Helen Regenstein Collection, 1971.326

IN addition to the fine examples of portraiture he owned, Count von der Schulenburg manifested a fondness for genre subjects. The charming and energetic *Boy Feeding a Dog* may, in fact, contain portraits as well—of two of Piazzetta's children: Giacomo, who would have been thirteen years old, and Barbara Angiola, age ten. Here Piazzetta captured the fleeting moment when, with a typical boyish gesture, the youth held a piece of bread just out of the dog's reach. The enigmatic presence of the girl and the spectacular quality of light that illuminates the boy's white shirt both serve to heighten the drama of this otherwise playful scene. Giacomo served as the model for many works by Piazzetta, including the painting of a young pilgrim entitled *The Beggar Boy*, now in The Art Institute of Chicago and originally from the Schulenburg family collection.

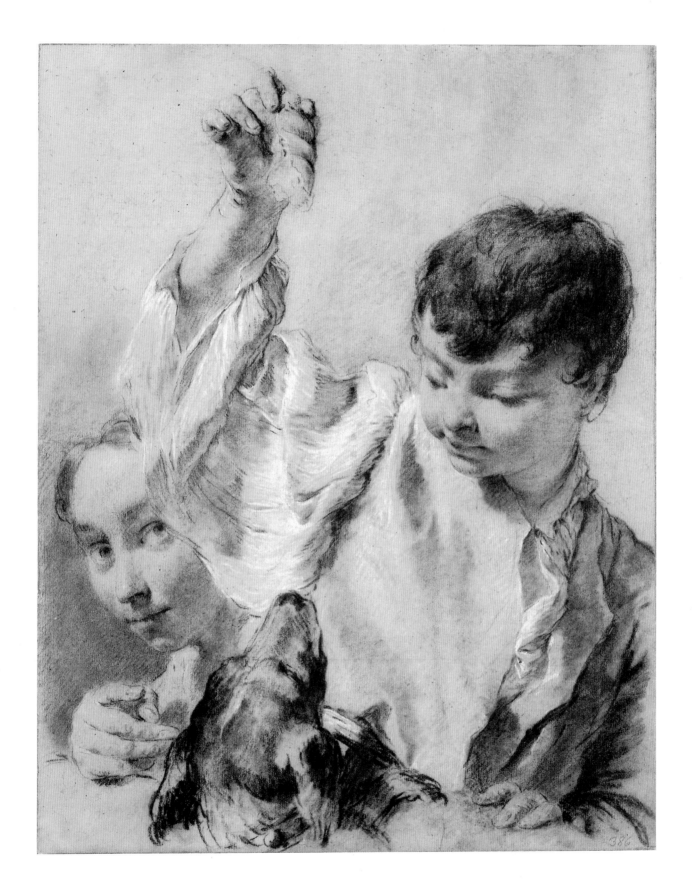

CATALOGUE NO. 13

Giovanni Battista Piazzetta

Portrait of a Man
Early 1730s

Black and white chalk with *estompe* on gray laid paper; laid down
393 × 297 mm (15½ × 11¾ in.)
Helen Regenstein Collection, 1971.333

*P*ORTRAIT *of a Man* demonstrates Piazzetta's ability to capture and convey the subtlest facial expressions. This memorable personality, perhaps a servant in the employ of Count von der Schulenburg, prompted one of the artist's most masterful chalk studies of a head, in which he has communicated the humanity of his subject with great tenderness.

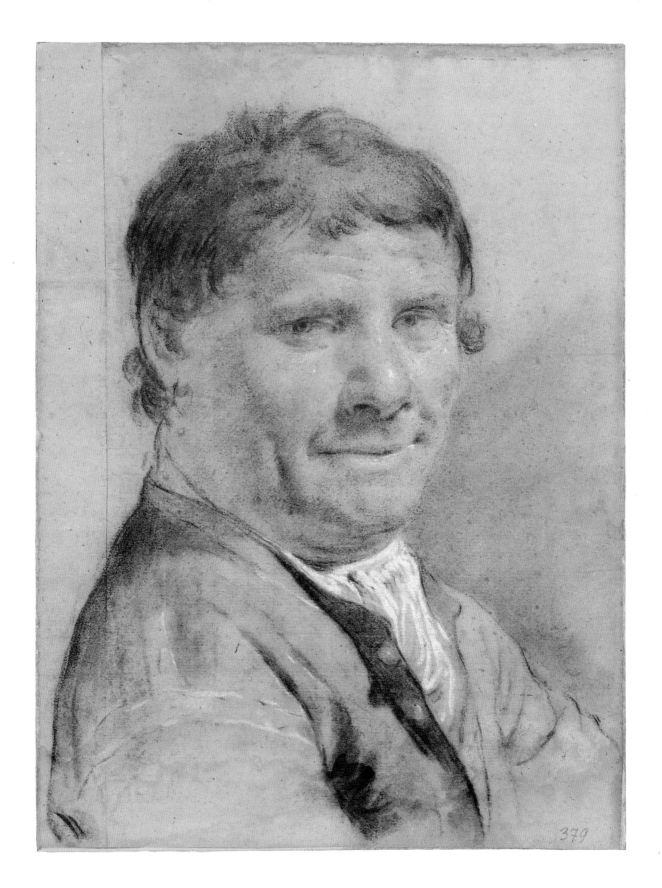

CATALOGUE NO. 14

Francesco Guardi

Italian, 1712–1793

Gateway near a Landing Bridge
Early or middle 1780s

Pen and brown ink with brush and brown wash over black chalk on ivory laid paper

304 × 456 mm (12 × 18 in.)

Helen Regenstein Collection, 1968.310

Capriccio with a Squall on the Lagoon
Late 1780s

Pen and brown ink with brush and brown wash over black chalk on ivory laid paper

270 × 386 mm (10¾ × 15¼ in.)

Helen Regenstein Collection, 1968.309

FRANCESCO Guardi was an eighteenth-century Venetian landscape painter whose work ranged from elaborate architectural compositions to delightfully free capriccios, or romantic fantasies, such as the two drawings shown here. The rapid, spontaneous play of his pen and brush across the paper often ignored the rough underdrawing of black chalk. The ruined arch shown in *Gateway near a Landing Bridge* occurs in many of Guardi's paintings and is quite similar to one in a canvas in the Galleria degli Uffizi, Florence.

Capriccio with a Squall on the Lagoon is another fine example of Guardi's late landscape capriccios. The stormy subject is especially well captured by the nervous and excited strokes of the artist's pen. Clearly, even in his late seventies Guardi was a draftsman of energy and originality, with a talent for expressing the more violent moods of the Venetian lagoon.

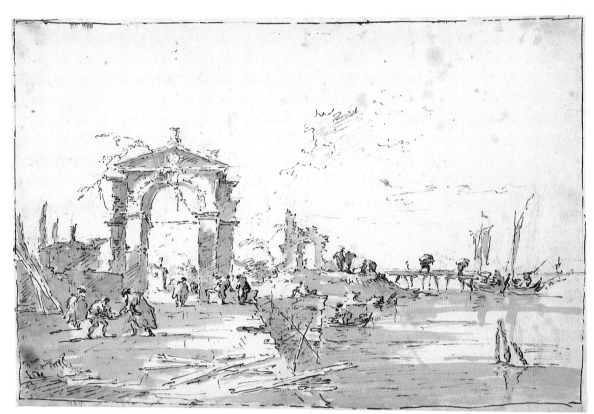

CATALOGUE NO. 15

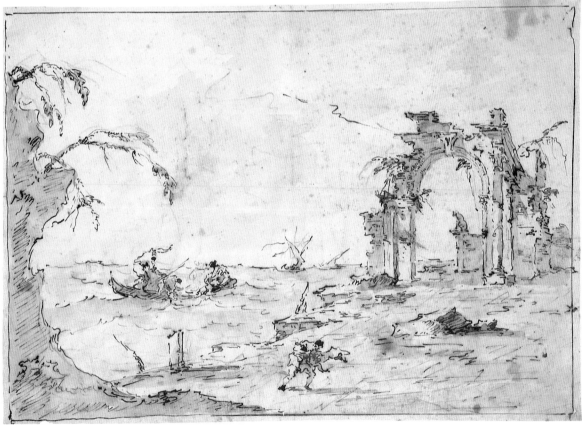

CATALOGUE NO. 16

Giovanni Battista Tiepolo

Italian, 1696–1770

The Meeting of Abraham and Melchizedek or
Moses Receiving the Offering of the Princes
Early 1720s

Pen and brown ink with brush and brown and gray wash over black chalk on ivory laid paper
370 × 510 mm (14⅝ × 20⅛ in.)
Inscribed recto, lower right, in graphite: *Tiepolo Ven./in e del.*
Given in memory of Carl O. Schniewind, 1958.554

THE Art Institute's collection of drawings by the great eighteenth-century Venetian artist Giovanni Battista (Giambattista) Tiepolo illustrates the major phases of his evolution as a draftsman and shows him to have been as varied and masterful in his private works as he was in the more public frescoes and altarpieces he created. The earliest of the group is this splendid sheet, which quite possibly is Tiepolo's first completed large-scale drawing in pen and wash. Signs that he struggled with the composition are evident in the extensive underdrawing in black chalk, over which he worked pen and wash within carefully defined boundaries. The rather studied approach evident in this ambitious and monumental sheet provides an illuminating contrast to the later works, which reveal Tiepolo's greater ease and sophistication in the medium.

This drawing traditionally was thought to represent the episode in Genesis (14:20) in which Melchizedek, ruler of Salem, bestowed gifts on Abraham, who then distributed them to his soldiers. Recently the alternative title *Moses Receiving the Offering of the Princes* (Exodus 35:27) has been suggested.

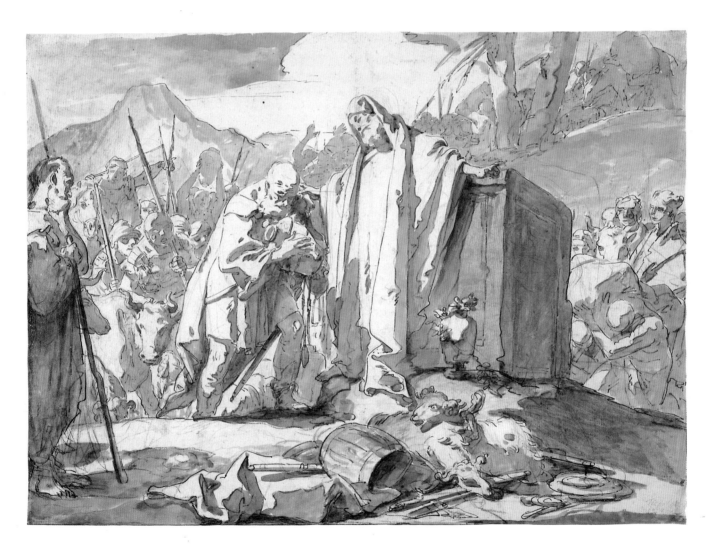

CATALOGUE NO. 17

Giovanni Battista Tiepolo

Three Angels Appearing before Abraham
c. 1728/30

Pen and brown ink with brush and brown and gray wash over black chalk on ivory laid paper
430 × 286 mm (17 × 11⅚ in.)
Margaret Day Blake Collection, 1970.41

THIS magnificent drawing probably dates from between 1728 and 1730, a few years after Tiepolo had painted a calmer, more lyrical version of the same subject in the archbishop's palace in Udine. In contrast to *The Meeting of Abraham and Melchizedek* (cat. no. 17), this sheet displays a greater freedom in handling; both pen and wash move across the page over preparatory black chalk underdrawing with a dynamic tonal rhythm that activates the composition as much as do the boldly conceived figures. Here Tiepolo has captured the dramatic moment (Genesis 18:2) when Abraham bows low before the three angels sent to him by the Lord to foretell the birth of his son Isaac.

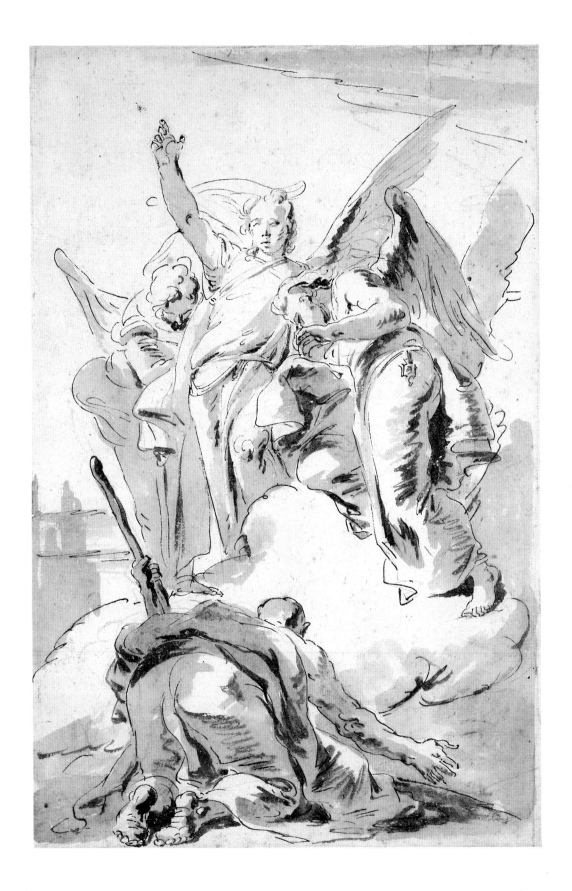

CATALOGUE NO. 18

Giovanni Battista Tiepolo

Fantasy on the Death of Seneca
c. 1740

Pen and brown ink with brush and brown wash over black chalk on white laid paper

340 × 240 mm (13⁷⁄₁₆ × 9½ in.)

Helen Regenstein Collection, 1959.36

*F*ANTASY *on the Death of Seneca* reveals Tiepolo at full maturity, when brilliant luminosity of wash and economy of means reached unsurpassed heights. The sheet has been dated about 1740 because of its closeness in spirit to Tiepolo's etched *Scherzi di Fantasia* of the 1740s. The scene is a fantasy, rather than a historically accurate rendering, on the death of the Roman philosopher, whom Emperor Nero ordered to commit suicide. Typical of Tiepolo is the mixture of tragedy and masquerade; the masked onlookers seem to heighten the tragic import of the scene by their menacing presence.

An interesting technical note is the artist's occasional practice, as here, of drawing on creased paper. The folds caused the pen and brush to skip in a way that increased the effect of wear and age that Tiepolo often intentionally gave his sheets.

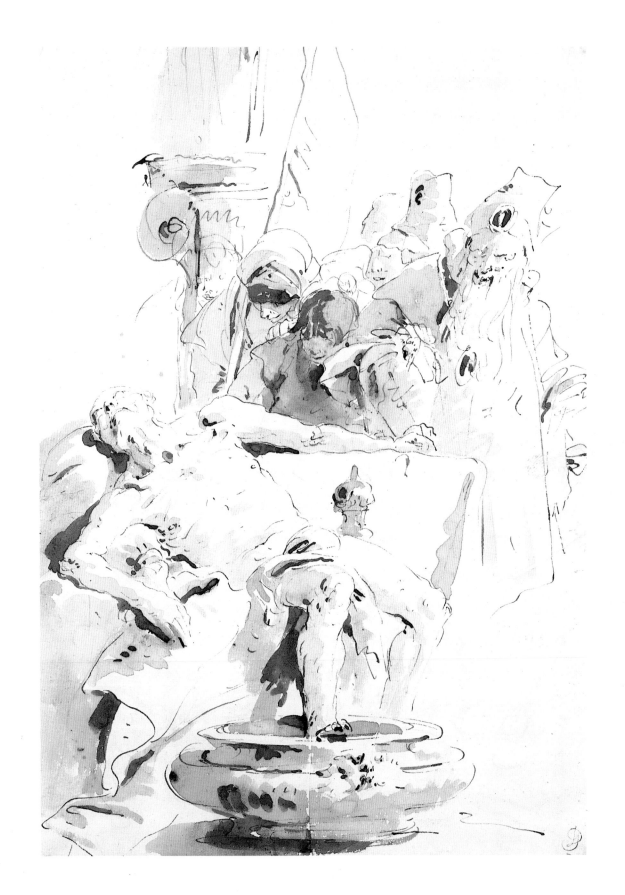

CATALOGUE NO. 19

Giovanni Battista Tiepolo

Punchinello's Repast

Late 1740s

Pen and brown ink with brush and brown wash over graphite on ivory laid paper

196 × 230 mm (7¾ × 9⅛ in.)

Helen Regenstein Collection, 1972.108

GIOVANNI Battista Tiepolo's first drawings featuring
Punchinello, the popular character of the Commedia dell'Arte,
are from the 1740s. The subject occurs at least eighteen times in his
drawings and served as the inspiration for many of the sheets,
numbering over a hundred, devoted to the subject by his son
Giovanni Domenico. This work pictures a group of Punchinellos
gathered around a kettle of soup. It is not clear how many persons
are involved in the repast—a little mystery no doubt cultivated
deliberately by the artist. The free and spontaneous execution of the
group reflects the lighthearted whimsy and good humor of
Giambattista's Punchinellos, in contrast to his son's more malevolent
and highly finished drawings of the subject.

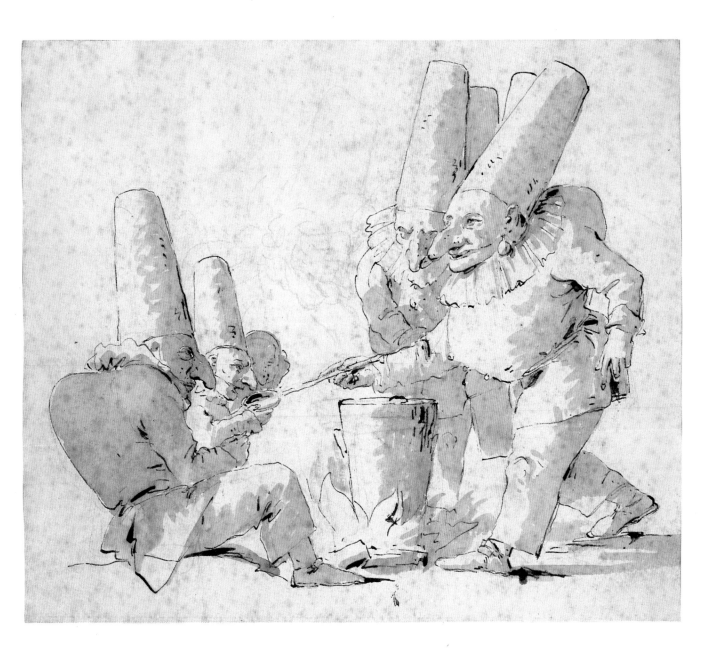

CATALOGUE NO. 20

Giovanni Battista Tiepolo

Rest on the Flight into Egypt
c. 1760

Pen and brown ink with brush and gray wash over black chalk on ivory laid paper
284 × 204 mm (11¼ × 8¹/₁₆ in.)
Helen Regenstein Collection, 1968.311

OVER the course of his career, Tiepolo made a number of variations on the subject of the Flight into Egypt. This delightful sheet is from the latest group, datable to around 1760 (prior to the artist's departure for Spain). It represents the final phase of Tiepolo's drawing style, when he omitted all nonessential elements. Here, the forms are evoked rather than articulated and seem to float on the page.

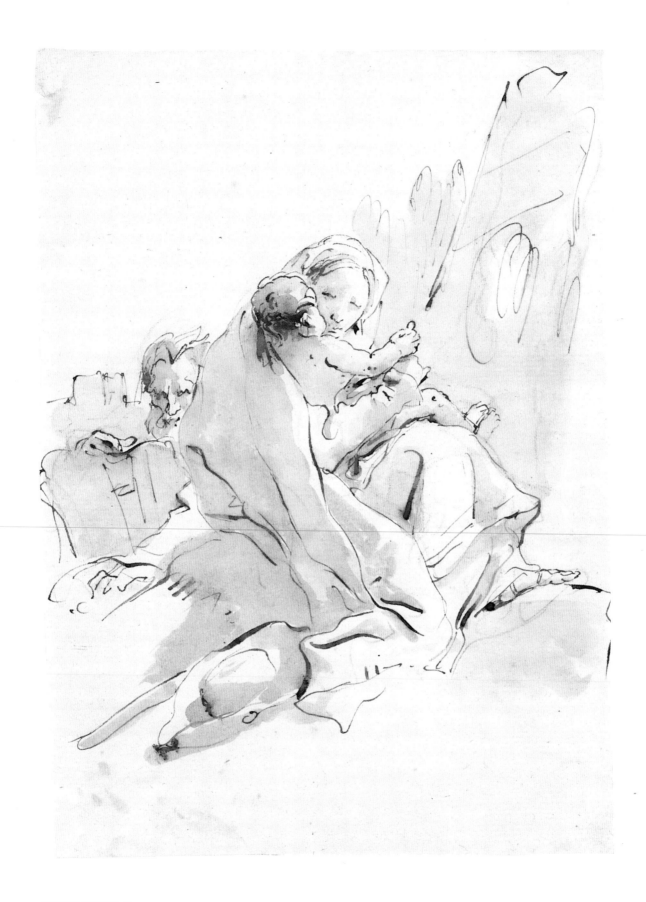

CATALOGUE NO. 21

Giovanni Domenico Tiepolo

Italian, 1727–1804

Jesus in the House of Jairus

c. 1790

Pen and brown ink with brush and brown and gray wash over black chalk on ivory laid paper

480 × 382 mm (19 × 15¹⁄₁₆ in.)

Inscribed recto, lower right, in pen and brown ink: *Dom Tiepolo f.*

UNLIKE Giovanni Battista, his father, Giovanni Domenico (Giandomenico) Tiepolo concentrated his graphic activity on the creation of large series elaborating specific themes. In his later years, Domenico made more than two hundred fifty drawings of religious subjects, known as "The Large Biblical Series" and probably intended as album drawings rather than as studies for works in another medium. They are almost identical in size (approximately 485 × 375 mm; 19¹⁄₁₆ × 14¾ in.) and are drawn with pen and wash in a tawny brown and gray watercolor over rough notations in black chalk.

The scene depicted so dramatically in this drawing is the Resurrection of the Daughter of Jairus, ruler of the synagogue—one of the miracles in the Life of Christ as told by Saints Matthew, Mark, and Luke. Especially forceful is the handling of the dark-brown wash, against which the white accents appear startlingly brilliant, as if a divine light has suddenly illuminated the scene.

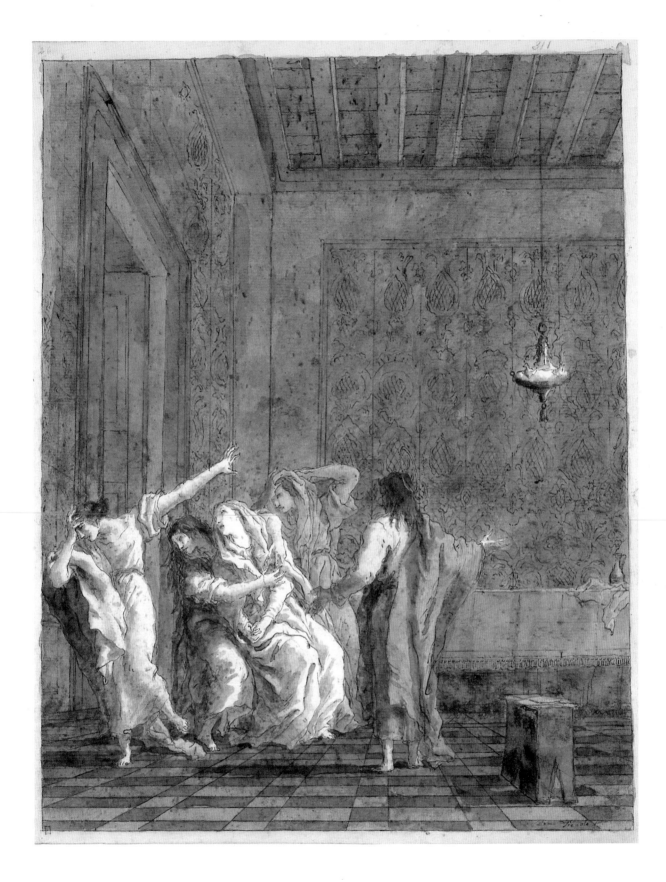

CATALOGUE NO. 22

Pietro Antonio de' Pietri

Italian, 1663–1716

Presentation in the Temple
c. 1715

Pen and brown ink with brush and brown wash over graphite, heightened with white gouache, on buff laid paper; laid down

407 × 273 mm (16⅛ × 10¹³⁄₁₆ in.)

Worcester Sketch Fund, 1972.323

PIETRO de' Pietri, a follower of the Roman Baroque painter Carlo Maratta, brilliantly demonstrated in this large, accomplished drawing his ability to handle the technique of pen and wash. The monumentality of the scene, with the imposing columns, clearly evokes the grandeur of Baroque Rome. It reflects as well the influence of Maratta, who returned to the calm, noble style of Raphael and the Carracci, moving away from the more dramatic style of such artists as Pietro da Cortona. Pietri made several studies of this composition, all of which are connected directly with the oval painting in Santa Maria de Via Lata in Rome, one of his late works.

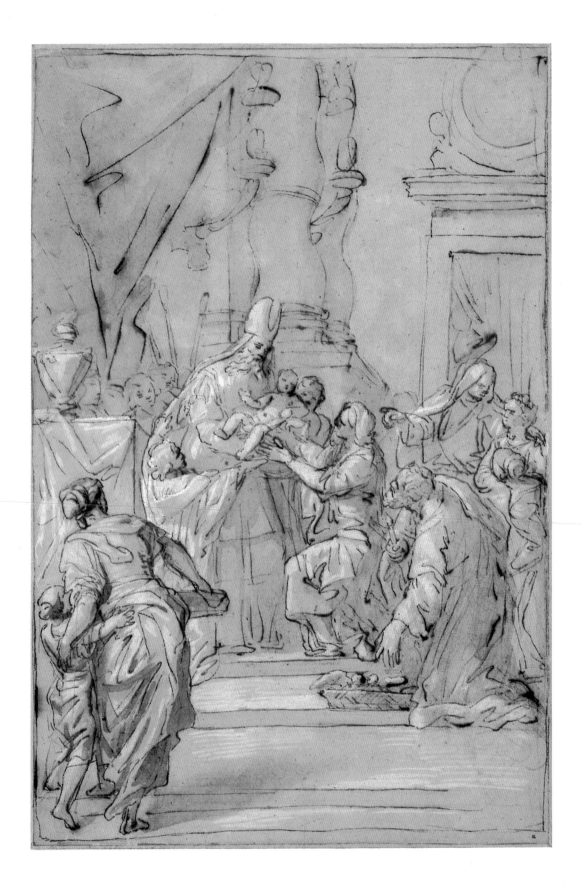

CATALOGUE NO. 23

Giovanni Battista Piranesi

Italian, 1720–1778

Palatial Courtyard

c. 1750

Pen and brown ink with brush and brown wash on ivory laid paper
260 × 390 mm (10⁵⁄₁₆ × 15⁷⁄₁₆ in.)
Inscribed recto, lower left, in pen and brown ink: *Piranesi*
Ada Turnbull Hertle Fund, 1963.139

EDUCATED in Venice as an architect and set designer, Giovanni
Battista Piranesi was first drawn to Rome in 1740 by his passion
for archaeology. He spent the rest of his career there etching his great
series, such as the *Views of Rome* and the *Prisons*, writing, publishing,
and directing a large workshop. Although he recorded the
monuments of Rome with great exactitude, Piranesi was also a master
of the architectural capriccio, or fantasy. His impulse for such
imaginative renderings was perhaps inspired by his early Venetian
training. This airy drawing of a palatial courtyard, executed around
1750 in Piranesi's early "scribbling" manner, suggests the rapidity
with which the artist set his dramatic visions down on paper.

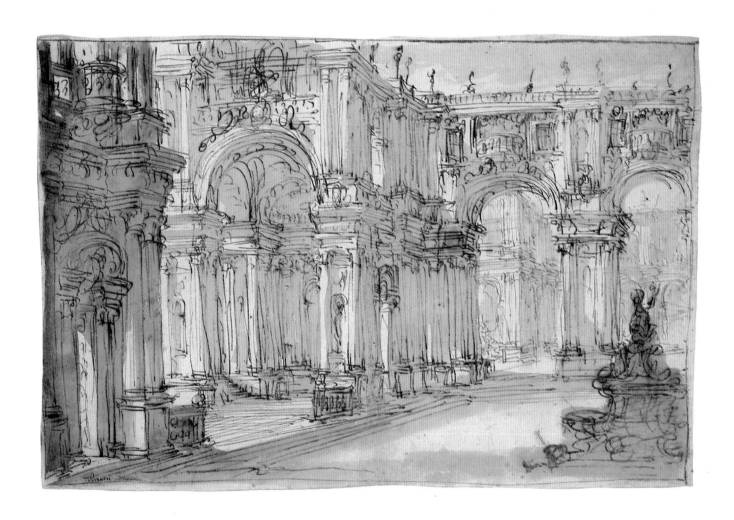

CATALOGUE NO. 24

Giovanni Battista Piranesi

Sheet of Six Figure Studies (recto)
Study of a Man with Arms Raised and Heads of Angels (verso)
c. 1770

Pen and brown ink on ivory laid paper

230 × 365 mm (9⅛ × 14⁷⁄₁₆ in.)

Inscribed recto, lower right, in pen and black-brown ink by a later hand:
Originale di Giam . . . Piranesi/celebre incisore

Margaret Day Blake Collection, 1959.3

THIS sheet of studies is undoubtedly based on Piranesi's direct observations in the streets of Rome, where he never ceased to find inspiration throughout his career. The assured and forceful handling of the reed pen indicates that the drawing dates from the last decade of the master's life. Piranesi often incorporated lively, witty human figures, surely derived from studies such as this, into his celebrated etchings of Rome's monuments and antiquities.

VERSO

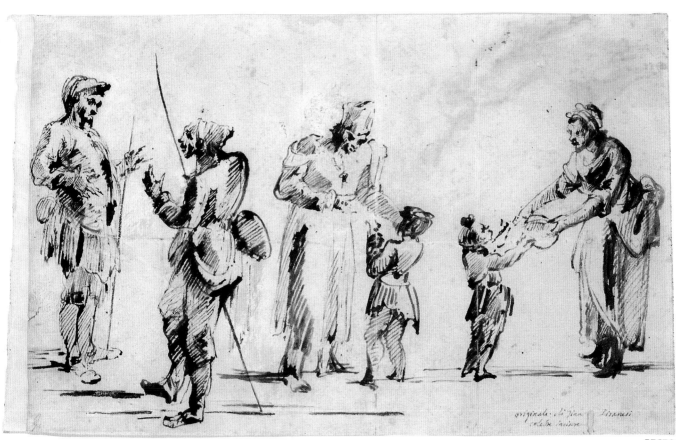

RECTO

CATALOGUE NO. 25

Albrecht Dürer

German, 1471–1528

Young Steer

c. 1493

Pen and black ink on ivory laid paper

176 × 140 mm (7 × 5⁹⁄₁₆ in.)

Inscribed recto, upper right, in brown ink by a later hand: *1508 Ad*

Clarence Buckingham Collection, 1965.408

FOR Albrecht Dürer's inquiring and reverent mind, all living things were manifestations of divine creation. Whether he drew a human body, an animal, or a plant, he always applied the same searching intensity of observation, missing no detail and never losing sight of the whole. *Young Steer* is probably one of his earliest animal drawings. In the close network of crossing lines and the general neatness of execution one still senses the proximity of Martin Schöngauer's medieval objet-d'art approach, although there is a feeling for plastic form, bone structure, and the resilience of living flesh that is totally beyond the range of the older master. The hind part of a steer in an almost identical posture appears in *The Prodigal Son*, Dürer's engraving datable to between 1494 and 1496. A self-portrait drawing in the Robert Lehman Collection, The Metropolitan Museum of Art, New York, which shares with the Art Institute's all the essential characteristics of style, is dated 1493.

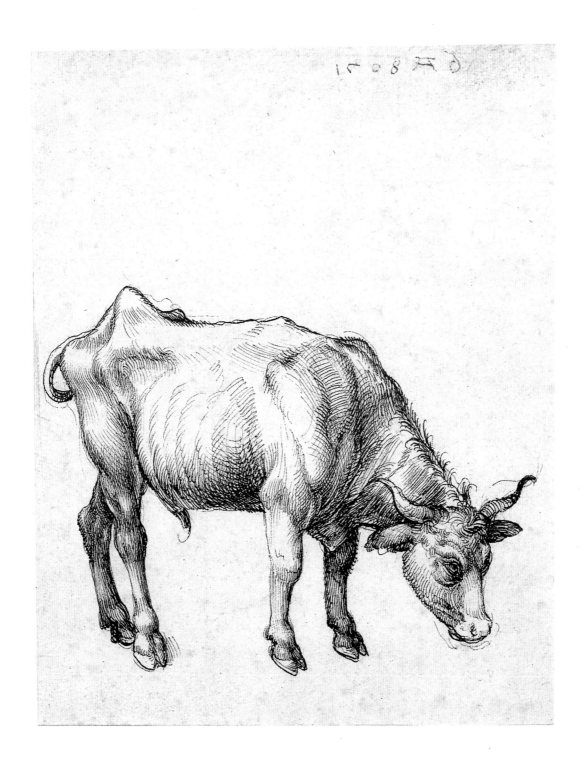

CATALOGUE NO. 26

Maerten van Heemskerck

Dutch, 1498–1574

Abigail

After 1536

Pen and brown ink on ivory laid paper
199 × 250 mm (7⅞ × 9⅞ in.)
Simeon B. Williams Fund, 1961.33

THE Dutch painter Maerten van Heemskerck spent the years between 1532 and 1536 in Rome, where he quickly fell under the spell of Michelangelo's heroic style. Upon his return to Holland, he became a leading proponent of the Mannerist School in Haarlem. He was a prolific draftsman and etcher; prints after his designs are very numerous, as well. Old Testament and allegorical subjects predominate in van Heemskerck's work. This drawing, which has been pricked for transfer to a metal plate, was engraved by an unknown hand for a set of Good Women of the Old Testament. Abigail, one of the six included in the set, saved the life of her husband, Nabal, when David became angry at him for refusing to pay tribute for the protection of his flocks. Abigail appeased David and his men by bringing them food, unbeknownst to her husband. When Nabal died shortly afterward, David took Abigail for his wife (1 Samuel 25).

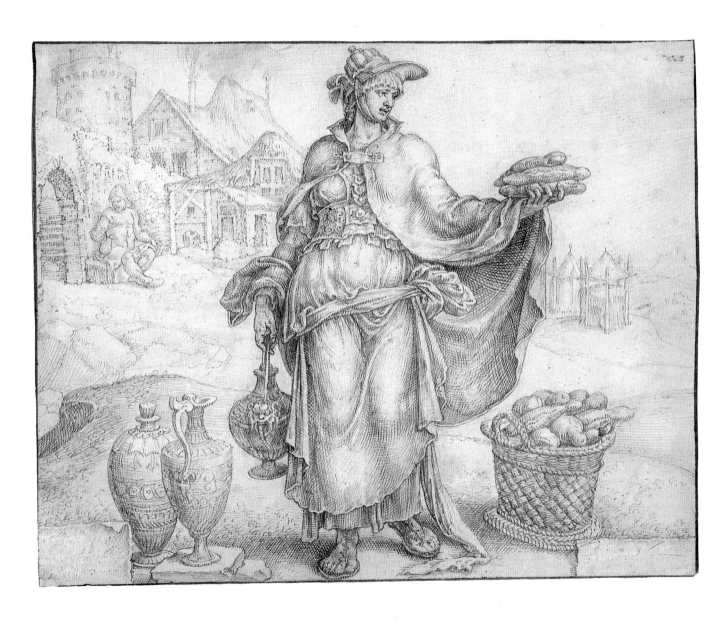

CATALOGUE NO. 27

Hendrik Avercamp

Dutch, 1585–1634

Two Old Men beside a Sled Bearing the
Coats of Arms of Amsterdam and Utrecht
1620/25

Pen and brush with watercolor on ivory laid paper
178 × 296 mm (7¹⁄₁₆ × 11¹¹⁄₁₆ in.)
Clarence Buckingham Collection, 1965.30

HENDRIK Avercamp, a deaf-mute, had keenly developed powers of observation. These and his earthy sense of humor are communicated in his numerous paintings and drawings of winter landscapes, all with many figures and vistas that extend gradually to a distant horizon. This drawing, rendered in Avercamp's delicate tints, is a fine example of the typical Dutch genre of "Pleasures on the Ice," generated in part by the severe cold wave endured by the Netherlands in the early seventeenth century. Here two old men greet a gentleman who is seated on a sled that bears the arms of Amsterdam and Utrecht and may have been a post-sleigh between those two cities.

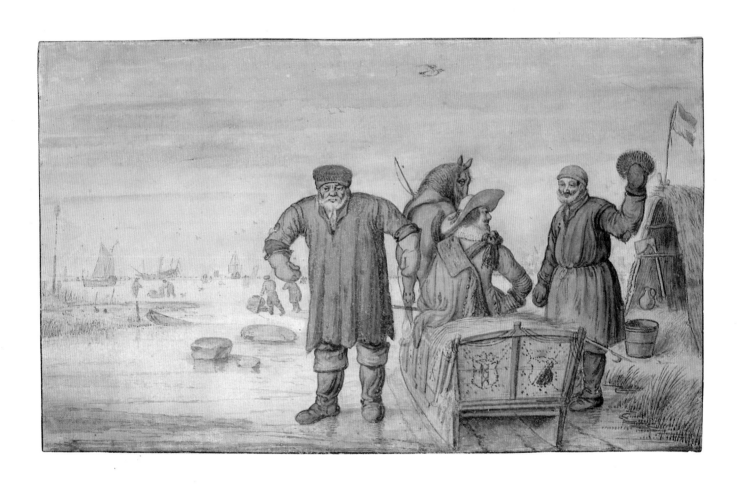

CATALOGUE NO. 28

Jacques de Gheyn

Dutch, 1565–1629

Three Gypsies
c. 1605

Pen and brown ink on buff laid paper
225 × 257 mm (8⅞ × 10³⁄₁₆ in.)
Margaret Day Blake Collection, 1959.2

TRAINED first as a glass painter and miniaturist, and then as an engraver under Hendrik Goltzius, Jacques de Gheyn belonged to the generation of artists that represented the final flowering of Northern Mannerism. Although his early style is characterized by flamboyant artifice, this drawing of three gypsies is typical of his later, more realistic style and dates probably to around 1605. De Gheyn, whose preoccupations included magic and witchcraft, was particularly fascinated by gypsies and fortune-tellers. With his younger contemporary, the French draftsman Jacques Callot, he shared a curiosity about and sympathy for these nomadic people. Two of the figures in this drawing, the woman in the center and the boy, appear again in a more elaborate study by de Gheyn, from which he made an engraving called *The Fortune-Teller*.

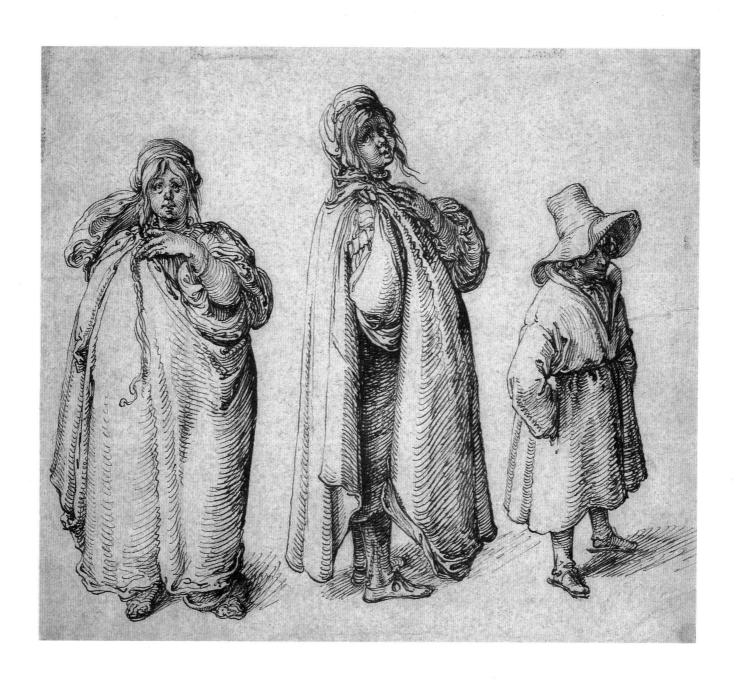

CATALOGUE NO. 29

Albert Cuyp

Dutch, 1620–1691

River Landscape

After 1645

Black chalk and brush with gray wash and yellow and brown watercolor on ivory laid paper

140 × 187 mm (5%6 × 7%6 in.)

Worcester Sketch Fund, 1967.383

THE son and pupil of the painter Jacob Cuyp, Albert Cuyp began his career by painting still lifes and interiors. Eventually, however, he became one of the foremost Dutch landscapists of his day, specializing in pastoral scenes and river subjects that are characterized by a breadth, delicacy, and simplicity of execution. Even in small dimensions, Cuyp's drawings demonstrate his greatness as a landscape artist. His drawings from about 1645 on have a sunny, almost southern atmosphere that seems to suggest that they were made in Italy. Apparently, however, Cuyp never visited that country. It is more likely that the warm tonality seen in this river landscape, thought to portray an area near Cuyp's native Dordrecht, reflects the influence of Italianate artists in Utrecht, such as Jan Both.

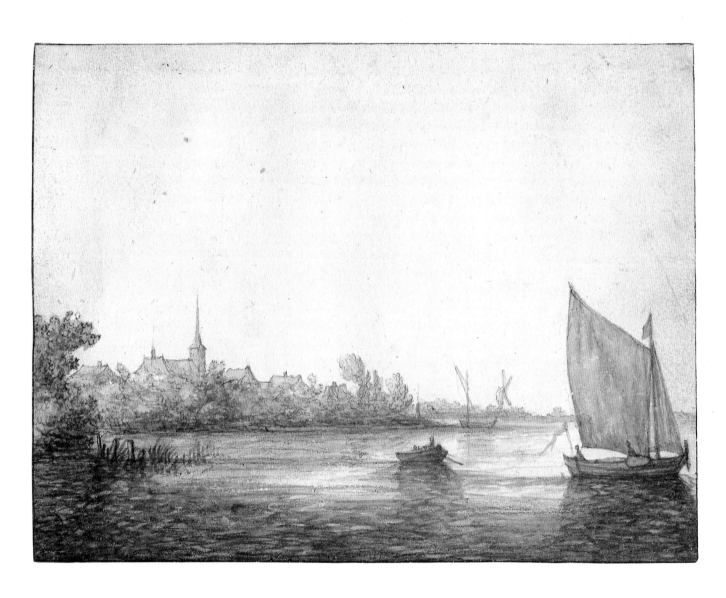

CATALOGUE NO. 30

Rembrandt van Rijn

Dutch, 1606–1669

Kostverloren Castle in Decay

c. 1657

Pen and brown ink with brush and brown wash, heightened with white gouache, on ivory laid paper

110 × 176 mm (4⅜ × 7 in.)

Clarence Buckingham Collection, 1961.49

REMBRANDT's graphic work is rightfully as famed as his paintings. Nowhere are the sureness of his line and the simple honesty of his vision more clearly expressed than in his landscape drawings, many of which deal with the open plains of his native Holland. Occasionally a specific monument captured Rembrandt's interest and received special attention with the addition of a painterly, chiaroscuro wash. In 1650 the once-splendid Kostverloren Castle was gutted by fire. About seven years later, Rembrandt made this haunting and moody study of the ruined building. It was the great scholar and connoisseur Frits Lugt who first identified the site in the drawing and who wrote in *Mit Rembrandt in Amsterdam* (Berlin, 1920): "The sad aspect of decayed splendor is masterfully expressed in Rembrandt's drawing, which accordingly must have originated in his last and very best period."

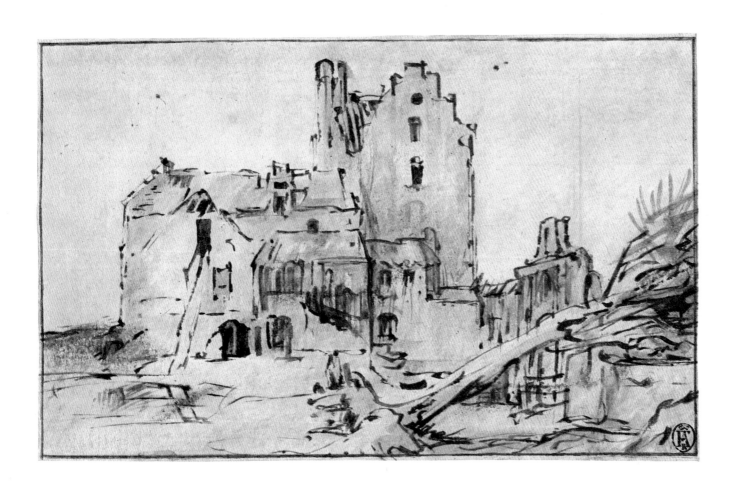

CATALOGUE NO. 31

Jacques Bellange

French, active c. 1602–1617

Rest on the Flight into Egypt
c. 1610/17

Pen and brown ink with brush and brown wash over black chalk, heightened with white gouache (partially oxidized), on ivory laid paper

240 × 200 mm (9½ × 7^{15}⁄₁₆ in.)

Inscribed recto, lower right, in pen and brown ink, probably in the artist's hand: *J. de Bellange*

Helen Regenstein Collection, 1967.17

IN the first half of the seventeenth century, when Paris offered little as a cultural center, one of the most important capitals of artistic production in France was the independent duchy of Lorraine. Among the most celebrated painters at the court of Lorraine, which was based about one hundred fifty miles from Paris in the city of Nancy, was Jacques Bellange, who spent his entire career in that city. Very few of his paintings have survived, however, and he is appreciated today primarily for his one hundred or so extant drawings and etchings. The graceful elegance of the figures and the brilliant chiaroscuro effect of the brown wash in this drawing of the Holy Family are trademarks of Bellange's style. Equally characteristic are the refined hands and deep-set eyes. Although the scarcity of his drawings prevents the establishment of a firm chronology, *Rest on the Flight into Egypt* clearly is a work of Bellange's maturity.

CATALOGUE NO. 32

Claude Lorrain (Claude Gellée)

French, 1600–1682

Panorama from the Sasso

1649/55

Pen and brown ink and brush and brown wash with white gouache over traces of black chalk and graphite on ivory laid paper

162 × 403 mm (6⁷⁄₁₆ × 15¹⁵⁄₁₆ in.)

Inscribed verso, center, in pen and brown ink: *la sasso Claudio Gellée/IV fecit*

Helen Regenstein Collection, 1980.190

ONE of the great masters of classical landscape painting, Claude Lorrain exercised a lasting influence on the art of landscape through his unlimited vistas and his unprecedented explorations of the varied effects of light and atmosphere. Although French by birth, by the age of thirteen he had already traveled to Rome. With the exception of brief trips to Naples and back to his native Lorraine, Claude lived the rest of his life in Rome, where he is said to have passed a quiet existence, spending his days in the hills of the Campagna, the region around Rome, studying the land and the strong southern sunlight.

This unusually broad view from the Sasso north of Rome is a superb example of Claude's mastery of subtle ink washes. The sheet was once part of an album of about eighty drawings that passed through the collections of Queen Christina of Sweden and of Prince Livio Odescalchi, illegitimate son of Pope Innocent XI. The drawing was removed from the album only recently, when the album was partly broken up and sold by the Odescalchi family.

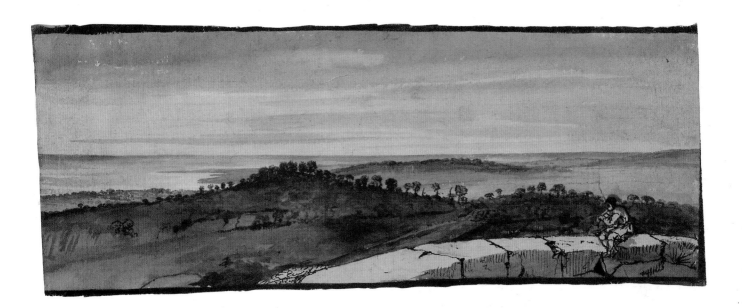

CATALOGUE NO. 33

Jean-Baptiste-Siméon Chardin

French, 1699–1779

Self-Portrait with a Visor
c. 1776

Pastel on blue laid paper mounted on canvas
457 × 374 mm (18 × 14¹³⁄₁₆ in.)

Inscribed verso, on the mount, by Juste Chardin (?): *Ce porteret de Jan Simeon Chardin apartien a Juste Chardin Rue Faubour St. germain a parys*

Clarence Buckingham Collection and Harold Joachim Memorial Fund, 1984.61

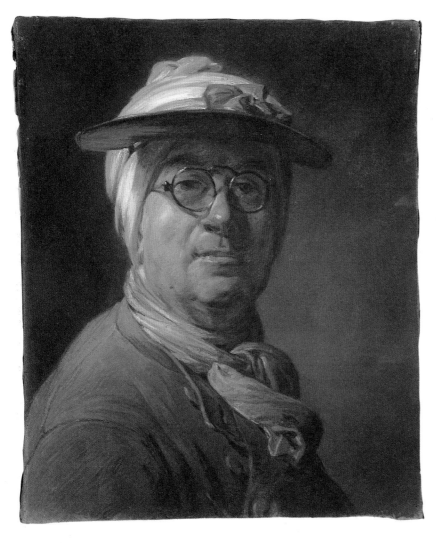

CATALOGUE NO. 34

AT the end of a long and highly successful career as a painter of still lifes and genre scenes, Jean-Baptiste-Siméon Chardin turned to a new medium and an unexplored subject, creating revolutionary and compelling portraits in pastel. Only twelve of these are known today; most famous among them are the various self-portrait compositions created over the course of his last decade, all of them depicting the artist in casual studio attire.

In 1775 Chardin submitted to the Salon (the official exhibition of members of the Académie des Beaux-Arts) his most audacious pastel of that year, *Self-Portrait with a Visor*, along with a companion portrait of his wife of many years, Françoise Marguérite Pouget. The following year, as was his habit, Chardin made a second version of the portrait of his wife (which he dated); a replica of his self-portrait was undoubtedly made at the same time. The first versions of this pair are now in the Musée du Louvre, Paris; the second versions, separated for

Portrait of Madame Chardin
1776

Pastel on blue laid paper mounted on canvas
457 × 378 mm (18 × 14¹⁵⁄₁₆ in.)
Inscribed recto, lower right, in brown chalk: *Chardin/1776*
Helen Regenstein Collection, 1962.137

almost two hundred years, were finally reunited in the Art Institute. The artist showed greater daring in the second versions, building upon the first but enlivening the figures with stronger accents of color and solidifying the forms in more sculptural terms. The head ribbons in both replicas also are more crisply defined than in the first versions. The Art Institute's pastels undoubtedly were created for the private delectation of the artist and his family: *Self-Portrait with a Visor* once belonged to the artist's brother, Juste Chardin.

These portraits not only are landmarks in the development of the art of pastel, but they also provide an illuminating insight into Chardin's working method. During his last years, the artist's style evolved toward greater internal animation and coloration, higher drama, and increased three-dimensionality. Replicas such as these clearly illustrate his subtle advances and reveal his private aspirations.

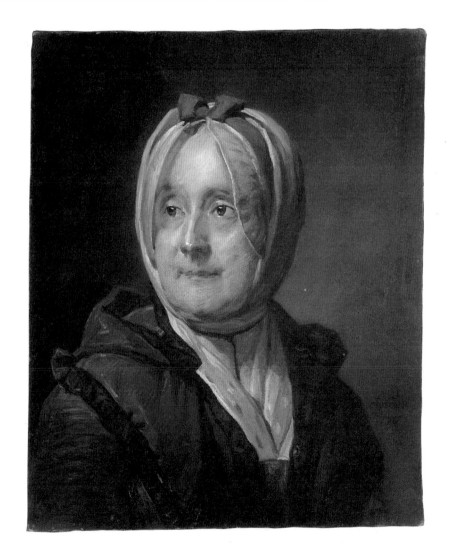

CATALOGUE NO. 35

Antoine Watteau

French, 1684–1721

The Old Savoyard

c. 1715

Red and black chalk with *estompe* on cream laid paper

360 × 224 mm (14¼ × 8⅞ in.)

Helen Regenstein Collection, 1964.74

ANTOINE Watteau was a prolific draftsman as well as an acclaimed master of the painted *fête galante*, or romantic picnic. Although he often relied upon his chalk studies for the figures in his paintings, his drawings were also created as independent works of art. This portrait of a humble Savoyard, unusual for Watteau, who focused mainly on courtly subjects, reveals the strength of his figure drawing. Around the turn of the eighteenth century, many of these gypsylike people from the Savoy region had flocked to Paris to eke out a living. This same elderly, salty type appears in several other drawings by Watteau, but none so completely expresses as does this drawing the artist's profound naturalism and humanity. The old man carries a box of curiosities on his back and a case possibly containing a marmot under his arm—all props for his street performances. Despite the tattered rags of the Savoyard, Watteau's portrayal holds no contempt, but rather invests the man with dignity, as he confronts the viewer with a shrewd and disquieting gaze.

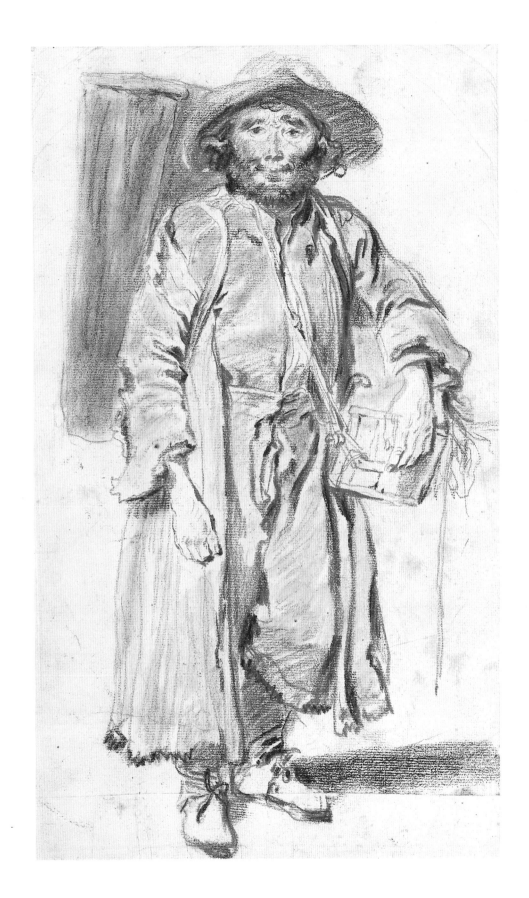

CATALOGUE NO. 36

Antoine Watteau

Study for The Feast of Love
c. 1717

Red chalk over graphite on ivory laid paper
195 × 264 mm (7¾ × 10⁷⁄₁₆ in.)
Gift of the Helen Regenstein Collection, Mrs. Henry C. Woods, and the
Wirt D. Walker Fund, 1975.343

WATTEAU rarely made preliminary studies for his paintings, and so the Art Institute is especially fortunate to have acquired this lively, full compositional sketch for his *Feast of Love* in the Gemäldegalerie, Dresden. Here Watteau crystallized his first thoughts for the design and atmospheric effects of the painting. Although the basic elements of the two compositions are the same, many alterations took place between this preliminary drawing and the finished canvas. Most of the changes seem to have been made for the purpose of elevating the subject of a romantic, outdoor party to a more idealized and poetic view of society. Whereas the drawing reveals the underlying influence of Peter Paul Rubens's bawdy *Kermis* (Musée du Louvre, Paris), in the painting the bucolic behavior of some of the couples became more refined and restrained.

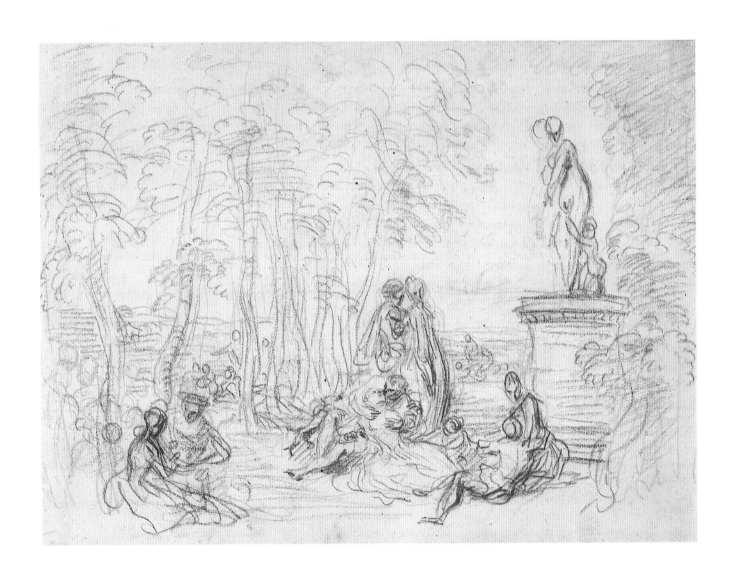

CATALOGUE NO. 37

François Boucher

French, 1703–1770

Boy Holding a Carrot

1738

Pastel on buff paper

306 × 241 mm (12⅛ × 9⁹⁄₁₆ in.)

Inscribed recto, upper left, in brown pastel: *F. Boucher 1738*

Helen Regenstein Collection, 1967.231

THE most famous painter and decorator in the reign of Louis XV, François Boucher seldom turned from his elaborate work on major painted compositions to lavish attention on a finished, independent work on paper. This charming and lively portrait, dated 1738, may be one of the artist's first, and finest, pastel drawings. The attentive gaze of the boy as he turns with lips parted as if to speak and the delicate rendering of his rosy skin invest the portrait with an extraordinary immediacy. The same young model, again holding a carrot, appears in at least two paintings of pastoral subjects by Boucher, one formerly in the Maurice de Rothschild Collection, Paris, and the other in the Walter P. Chrysler Collection, Norfolk, Virginia.

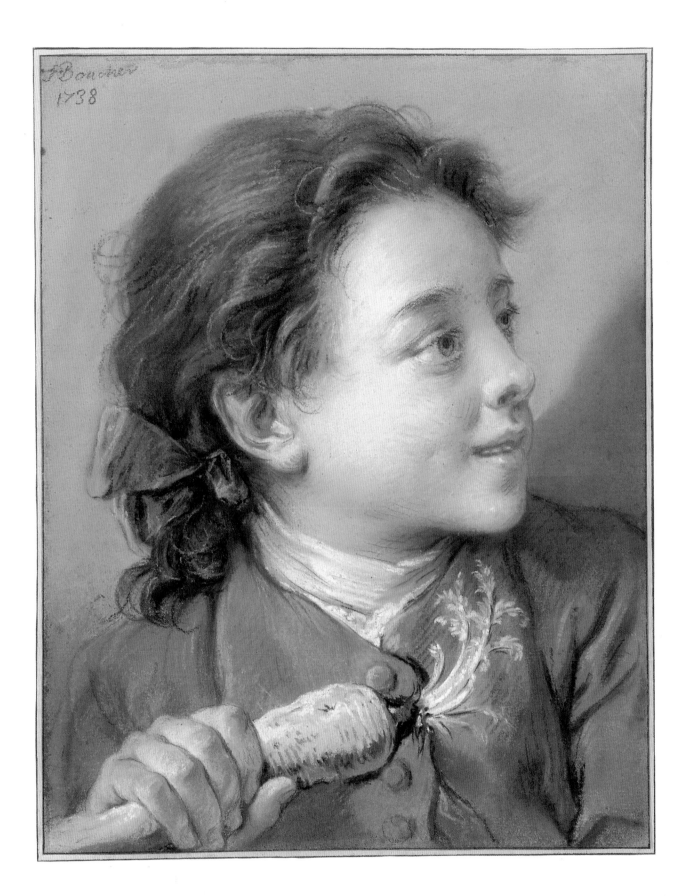

CATALOGUE NO. 38

François Boucher

Study for a Triton
1748

Black and white chalk with traces of red chalk and *estompe* on brown laid paper
220 × 270 mm (8¾ × 10¹⁵⁄₁₆ in.)
Helen Regenstein Collection, 1965.240

BOUCHER'S drawings of male anatomy reveal his thorough academic training. This vigorous drawing is a study for the triton that appears at the lower right of the artist's oil painting *Sunrise* (1753). That canvas and its pendant, *Sunset*, both in the Wallace Collection, London, were made as designs for tapestries executed by the Gobelin manufactory. The commission initially came to Boucher in 1748; the tapestries were completed by 1754. Another drawing of a triton for *Sunrise*, also in the Wallace Collection, appears to have been made at the same time and from the same muscular model as this forceful study.

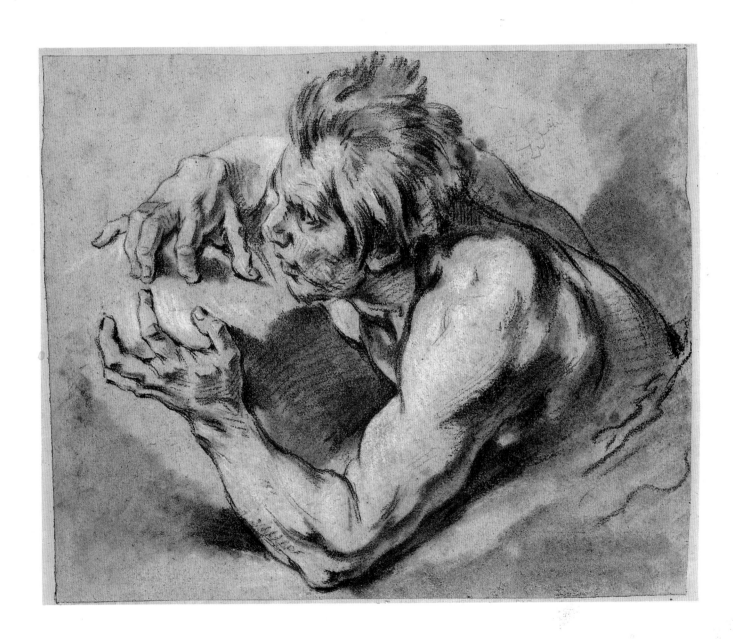

CATALOGUE NO. 39

François Boucher

A Nymph: Study for Apollo and Issa
c. 1749

Black, red, and white chalk with estompe on buff laid paper
320 × 450 mm (12¹¹⁄₁₆ × 17¹³⁄₁₆ in.)
Helen Regenstein Collection, 1967.231

I N contrast to the solid, almost sculptural quality of Boucher's
studies of male figures, his languid female forms often display a
Mannerist idealization of the figure and traditional academic
avoidance of firsthand study of female anatomy. This preparatory
drawing represents Boucher's first thought for one of the nymphs in
the lower left corner of the painting *Apollo and Issa* (Musée des Beaux-
Arts, Tours), which was painted for Louis XV in 1750. Although the
arms of the unseen figure are clear reminders that, like most of
Boucher's drawings, this sheet functioned as a preparatory study, the
elegance of the nymph's form marks this as one of his most
captivating works in its own right.

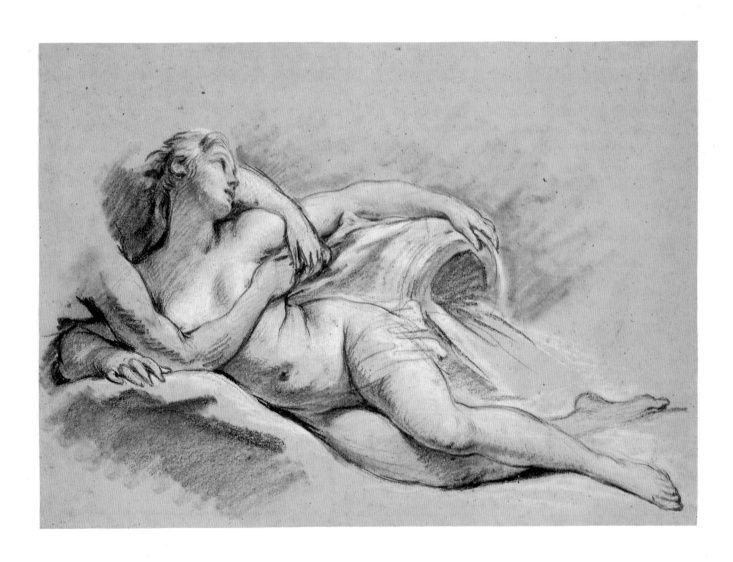

CATALOGUE NO. 40

Jean-Honoré Fragonard

French, 1732–1806

A Bull of the Roman Campagna
c. 1756/61

Brush and brown wash over black chalk on ivory laid paper
363 × 493 mm (14⅜ × 19½ in.)
Helen Regenstein Collection, 1962.116

FOR Jean-Honoré Fragonard, as for many young French artists of the eighteenth century, the period of study in Rome awarded him by the Académie des Beaux-Arts was to play a decisive role in the development of his art. Fragonard's extraordinary ability to capture the effects of light with the wash technique is nowhere more apparent than in this masterful drawing of a bull standing just inside the entrance of a hay barn. A second bull and the sketchy figure of a woman at the far left are suggested in the most subtle terms, as if their forms were all but dissolved by the light streaming through the doorway. Applied with great freedom over summary outlines in black chalk, the brown washes evoke a sense of dazzling, southern sunlight. The sheet is thought to date from Fragonard's first stay in Rome, which began in December 1755; during this period of study, the artist took great pleasure in exploring the countryside around Rome and recording his observations in both red chalk and wash drawings.

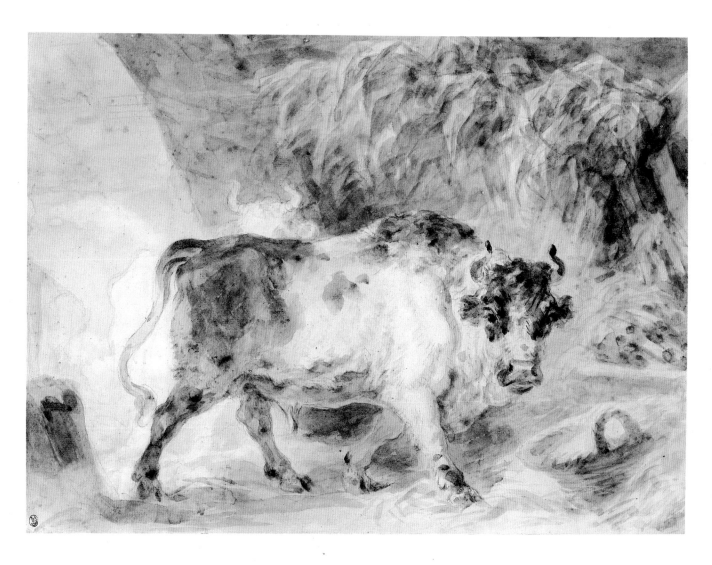

CATALOGUE NO. 41

Jean-Honoré Fragonard

Satyr Pressing Grapes beside a Tiger
1774

Brush and brown wash over black chalk on ivory laid paper
346 × 247 mm (13¹¹⁄₁₆ × 9¹³⁄₁₆ in.)

Inscribed recto, lower right, in pen and brown ink: *H. Fragonard Dresden 1774*

Gift of Mr. and Mrs. Robert J. Hamman in honor of Suzanne Folds McCullagh, 1982.500

FRAGONARD, like Watteau and others before him, was greatly influenced by the color and earthy humor of the paintings of Peter Paul Rubens and took many opportunities to study his works when he traveled. This lively brown-wash drawing is a free sketch by Fragonard of a painting in Dresden that was attributed to Rubens in Fragonard's day but is now given to a follower. From Fragonard's inscription we learn that the drawing was made in Dresden in 1774, upon the artist's return from a tour in Italy with the marquis de Marigny. While the composition, with the ruddy-faced satyr and pudgy blond children, is unmistakably Rubensian, Fragonard transformed the original with his own personal, powerful handling of the brush and wash.

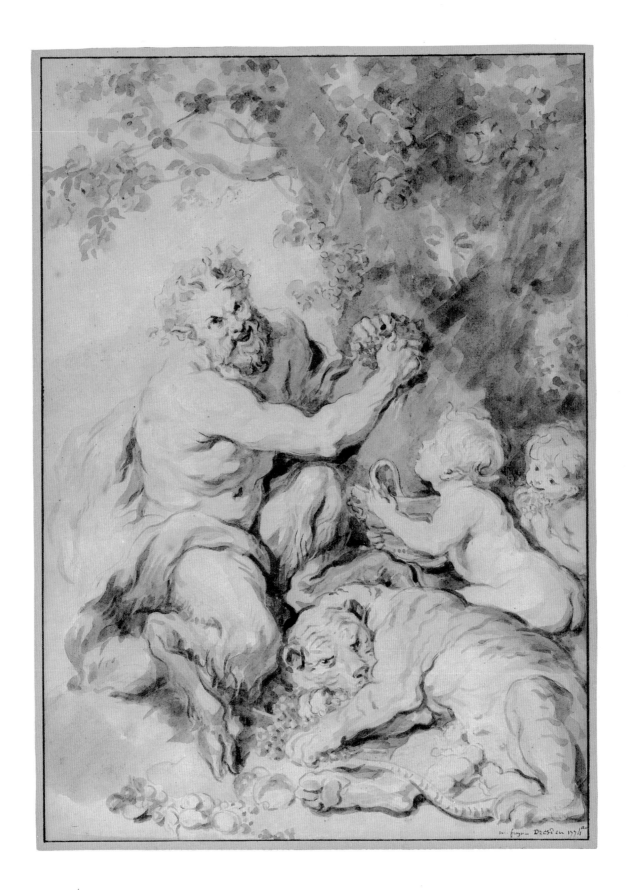

CATALOGUE NO. 42

Hubert Robert

French, 1733–1808

An Artist Seated in the Ruins of the Colosseum
c. 1759

Red chalk and *estompe* on ivory laid paper
408 × 530 mm (16⅛ × 20¹⁵⁄₁₆ in.)
Gift of Mr. and Mrs. William O. Hunt, and Prints and Drawings
Purchase, 1982.45

ONE of Hubert Robert's favorite sketching sites in Rome was the Colosseum, which he drew repeatedly during the course of his eleven-year stay in the city (1754–65): Robert and Jean-Honoré Fragonard, his fellow student at the French Academy, made several sketching expeditions together to the Colosseum; in at least one instance they both made red-chalk drawings of the very same spot, indicating that they were seated beside each other. Robert was fascinated particularly by the labyrinthine passageways inside the ancient arena, and by the ongoing excavations of the site under the sponsorship of Pope Benedict XIV. In this oval composition a young artist, perhaps Robert himself, is seen sketching in one of the crumbling vaults of the amphitheater. Robert allowed himself some liberties with the architecture, blending what he actually saw with his own romantic vision in a manner that recalls the grand architectural fantasies of his acquaintance Giovanni Battista Piranesi.

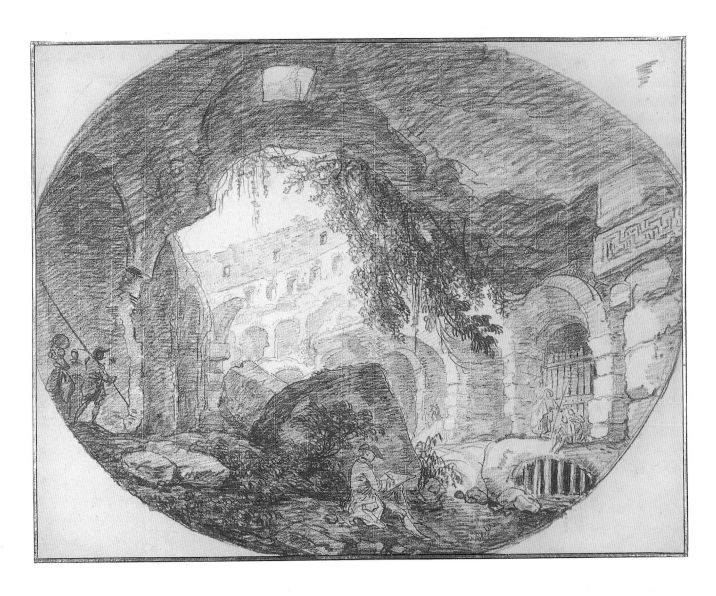

CATALOGUE NO. 43

Gabriel de Saint-Aubin

French, 1724–1780

Gabriel de Saint-Aubin Executing the Portrait of the Bishop of Chartres
1768

Pen and black ink with brush and gray wash over graphite on ivory laid paper
Diameter 170 mm (6¾ in.)

Inscribed recto, lower center, in black ink: *Gabriel de S'Aubin fecit 1768*;
bottom, in pen and brown ink, by Charles Germain de Saint-Aubin
(elder brother), *M. L'Eveque de Chartres n'avait jamais voulu consentir qu'on
le peignit, m. le Comte de Maillebois me donne la facilité de faire ce portrait au
travers d'un paravent pendant qu'il dinoit avec ce prelat.*

Worcester Sketch Fund, and Gifts of Mr. and Mrs. Robert Meers, Mr. and Mrs.
Roy Friedman, Mrs. Charles Folds, and Mrs. George B. Young, 1981.152

GABRIEL de Saint-Aubin was one of the most individual and
spirited draftsmen of the eighteenth century. As he
approached the last decade of his career, Saint-Aubin became
increasingly preoccupied with making formal portraits of dignitaries.
In the case of the bishop of Chartres—who would never consent to
sit for a portrait—the artist was forced to employ underhanded
methods in pursuit of his goal. This highly finished drawing of 1768
depicts the amusing evening when Saint-Aubin drew the bishop's
portrait from behind a folding screen while the bishop dined with
the count and countess de Maillebois. Numerous details—such as
the waiter entering with a tray of food, the little dog emerging from
his house, and the look of dawning suspicion on the bishop's face—
lend an air of actuality to the scene. In contrast to Saint-Aubin's
characteristic realism is the inclusion of an elevating allegorical
element, the genie, who attends the artist with the illuminating lamp
of inspiration.

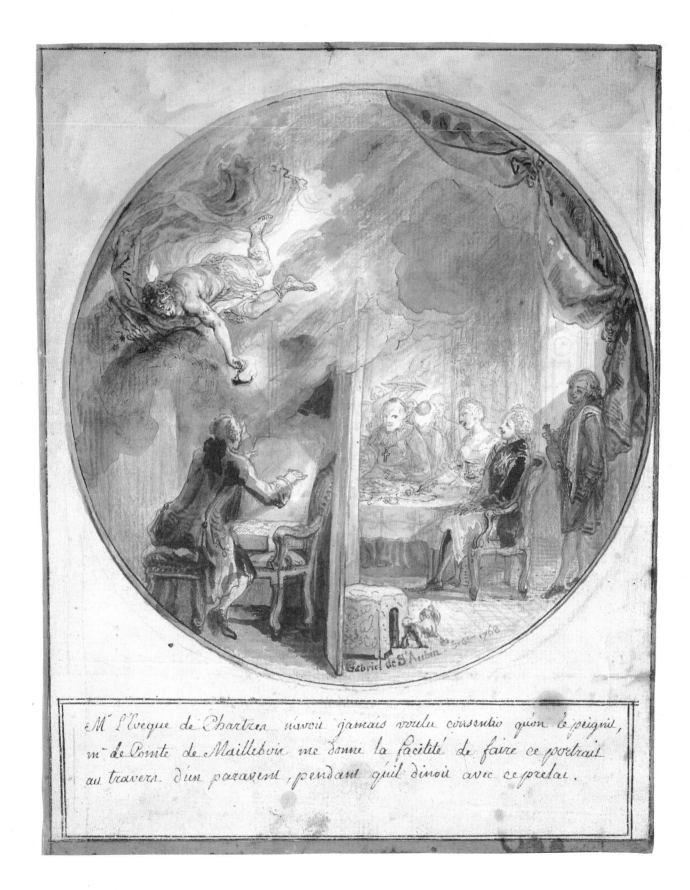

Mr L'Eveque de Chartres n'avoit jamais voulu consentir qu'on le peignit, mr de Comte de Maillebois me donne la facilité de faire ce portrait au travers d'un paravent, pendant qu'il dinoit avec ce prelat.

Jacques-Louis David

French, 1748–1825

•

The Departure of Marcus Attilius Regulus for Carthage
1785/86

Pen and black ink with brush and gray wash over black chalk, heightened with white gouache, on grayish-blue laid paper

315 × 415 mm (12½ × 16⁷⁄₁₆ in.)

Clarence Buckingham Collection, 1976.58

AS a draftsman and as a painter, Jacques-Louis David was the most influential exponent of the French Neoclassical style. In this drawing, which is characteristic of his preference for Roman historical and allegorical subject matter, David captured a moment of heroic self-sacrifice, when the consul Marcus Attilius Regulus left Rome—despite the entreaties of his wife and friends—to go to a martyr's death at the hands of the Carthaginians. The drawing shows the central figure group, counterbalanced by a ghostly swooning figure at the right, for one of two compositions that David worked on for the king and planned to submit to the Salon of 1787. When commissions for the Salon were judged in May 1786, the composition for which this drawing is a study was not selected; as a result, the painting never was realized. Nevertheless, David's preparatory studies rarely approach so nearly as does this sheet the classical polish and refinement of his paintings.

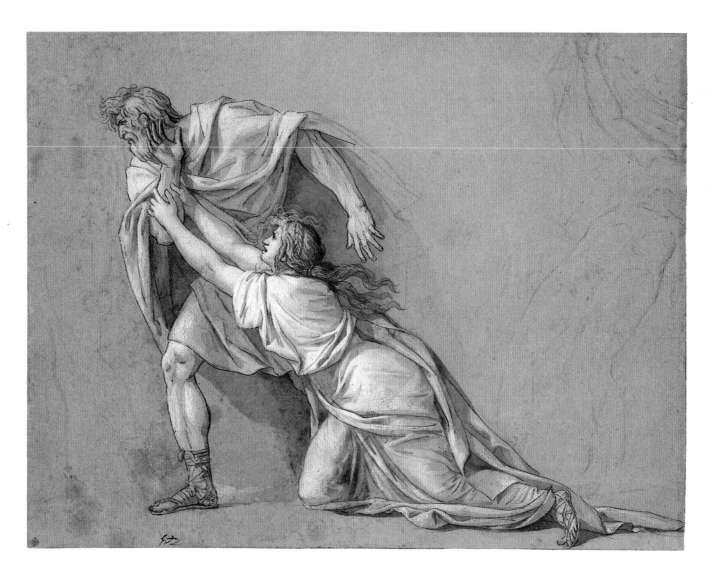

CATALOGUE NO. 45

Jacques-Louis David

Portrait of Jeanbon Saint-André
1795

Brush and black ink with gray wash, heightened with white gouache, on ivory laid paper

Diameter 182 mm (7¼ in.)

Inscribed recto: lower center, in brush and black ink, *L. David*; lower margin, on the mount, in pen and brown ink, *Donum amicitiae. amoris solatium. David faciebat in vinculis anno R. fr 3 (1795) messidoris 20*

Helen Regenstein Collection, 1973.153

DURING the French Revolution, David became a deputy and voted for the execution of Louis XVI. Upon the fall of Robespierre in July 1794, many revolutionaries, including David, were imprisoned. During his incarceration the artist drew this highly finished portrait of Jeanbon Saint-André (1748–1813), a fellow prisoner with whom he quickly developed a deep bond of friendship. The warm regard that David felt for the sitter is borne out by the Latin inscription: "A gift of friendship. solace of affection. David made this in chains in the third year of the French Republic (1795) Messidor 20 [July 8]." The drawing's round format and small scale probably reflect David's attempt to make the most of the limited materials that were available to him. The result, despite the difficult circumstances under which the portrait was created, is a refined and eloquent characterization of his friend which reveals the artist's inherent realism despite the Neoclassical style of most of his work.

CATALOGUE NO. 46

Anne-Louis Girodet-Trioson

French, 1767–1824

Portrait of Jean-Baptiste Belley
c. 1797

Graphite and *estompe*, heightened with white gouache, on cream wove paper
354 × 272 mm (14 × 10¾ in.)
Inscribed recto, lower left, in graphite: *A. L. Girodet*
Helen Regenstein Collection, 1972.156

A student of Jacques-Louis David, Anne-Louis Girodet-Trioson was something of a rebel who developed a Romantic temperament and a tendency toward the poetic of which his teacher disapproved. However, Girodet's precise execution in this portrait is not unlike that of David in his portrait of Jeanbon Saint-André (cat. no. 46). The composition of Girodet's drawing is identical to that of his painting of the same subject made in 1797 (Musée de Versailles). It is not known whether the drawing is a study for the painting or a souvenir of it. Certainly, the polished handling in no way interferes with the forceful characterization of Jean-Baptiste Belley, a native of Santo Domingo who was elected to the National Convention in 1793 and who helped lead the Santo Domingan uprisings against France in the first years of the nineteenth century. His thoughtful gaze and sensitive hands suggest an extraordinary personality.

Girodet chose to show Belley leaning on a marble socle topped with the bust of G. T. Raynal, the only philosopher of the Enlightenment to affirm that all men are created equal regardless of the color of their skin. Raynal condemned slavery and colonialism even before the Revolution.

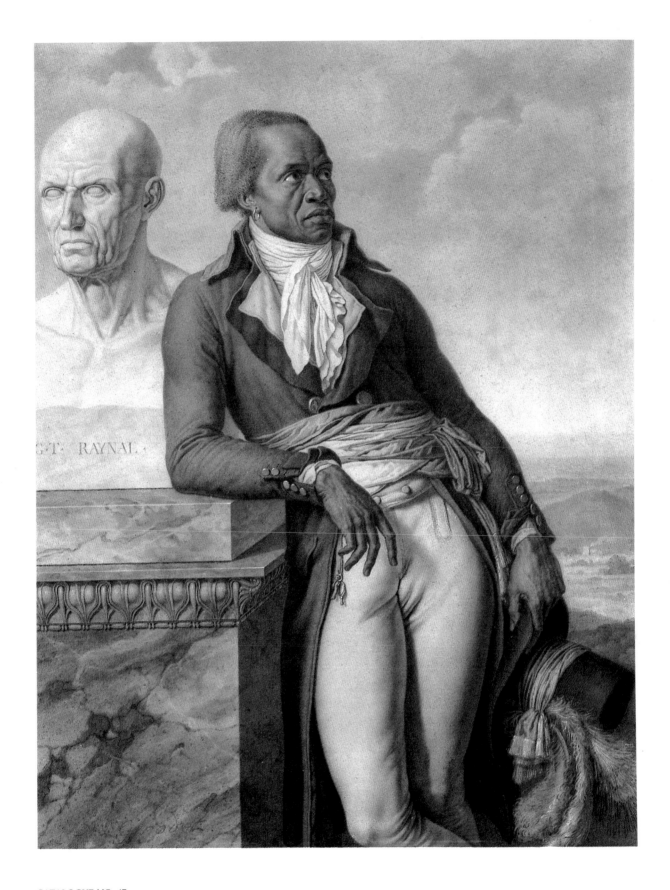

CATALOGUE NO. 47

Jean-Auguste-Dominique Ingres

French, 1780–1867

Portrait of Charles Gounod
1841

Graphite on cream wove paper
300 × 230 mm (11⅞ × 9⅛ in.)

Inscribed recto, lower right, in graphite: *Ingres à son
jeune/ami M. Gounod/Rom 1841*

Gift of Charles Deering McCormick, Brooks McCormick,
and Roger McCormick, 1964.77

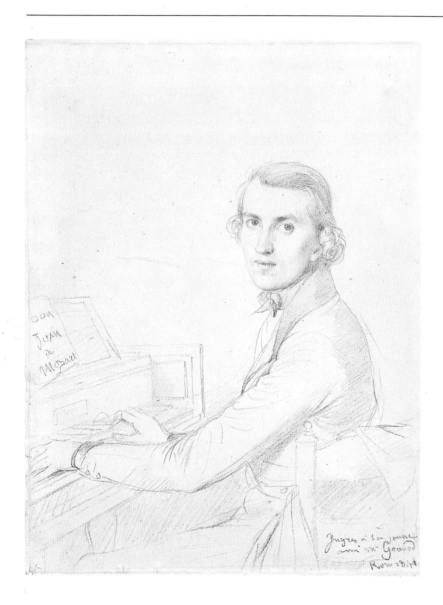

IN addition to his brilliance as a painter, Jean-Auguste-Dominique Ingres's superb technical mastery of the graphite medium and the psychological penetration he achieved make him one of the great portrait draftsmen of the nineteenth century. The delicate drawing of Charles Gounod was made in 1841, the very year the young musician, as winner of the Prix de Rome for music, arrived at the French Academy in Rome. At that time Ingres was still director of the Academy, and he and Gounod struck up a friendship based on their mutual love of music. They shared a special enthusiasm for Mozart's *Don Giovanni*, and in this drawing Ingres depicted Gounod seated at a piano with the Mozart score in front of him on the music stand.

Portrait of Madame Charles Gounod
1859

Graphite on cream wove paper

256 × 202 mm (10⅛ × 8 in.)

Inscribed recto, in graphite: lower left, *à/son cher ami Gounod/Ingres Del vit/1859*; upper right, *Portrait of M^e. Ch^{les} Gounod*

Gift of Charles Deering McCormick, Brooks McCormick, and Roger McCormick, 1964.78

Eighteen years after Ingres drew the portrait of Gounod he made this drawing of Anna Zimmerman, who had married Gounod in 1852. She was thirty-nine when she posed for Ingres. It is clear in both the pose of the sitter and the scale of the drawing that Ingres intended this portrait to complement the 1841 portrait of Gounod. Although the artist was nearly eighty by this time, the sheet demonstrates the extraordinary control and delicacy of handling that always characterized Ingres's graphite portraits.

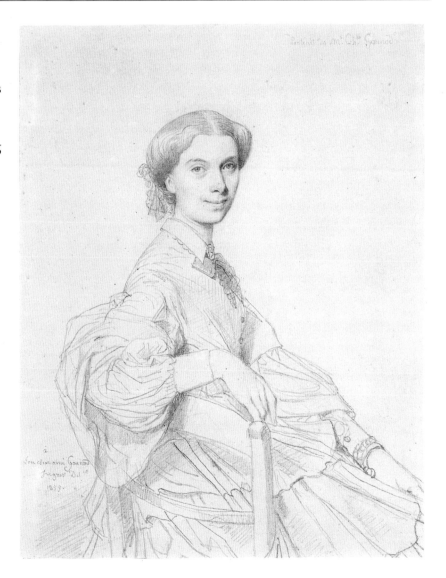

Francisco de Goya y Lucientes

Spanish, 1746–1828

Be Careful with That Step! (recto)
c. 1805

Brush with black ink and gray and black wash on ivory laid paper

Sketch of a Dancing Girl (verso)

Brush with gray wash

Inscribed recto: lower margin, in graphite, *Cuydado con ese paso*; upper margin, in pen and brown ink, *30*

264 × 182 mm (10⁷⁄₁₆ × 7³⁄₁₆ in.)

Helen Regenstein Collection, 1958.542

A respected artist at the Spanish court and Principal Painter to the King, Francisco de Goya y Lucientes was nevertheless an unconventional artist who allowed his unique and often bizarre imagination to color even the most straightforward subject matter. This charming portrayal of the carefree exuberance of youth is tempered by the warning Goya inscribed below the composition: "Be careful with that step!" The slightly ominous tone reminds us that grief is never far from happiness. This sheet is number 30 from the "Dark Border Set" (called Album E), which originally may have contained as many as fifty drawings by Goya, although only twenty-four survive today. These drawings have been dated about 1805, six years after Goya published his famous series of etchings entitled *Los Caprichos*.

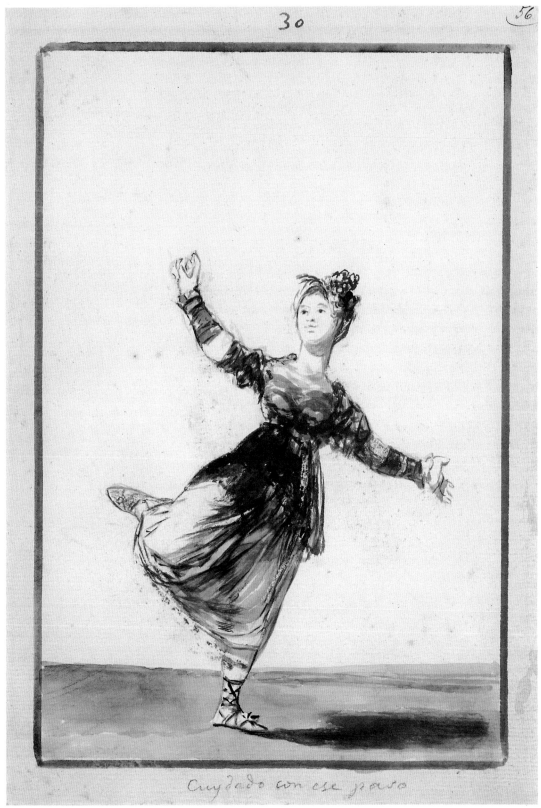

Cuydado con ese paso

CATALOGUE NO. 50

Francisco de Goya y Lucientes

Three Soldiers Carrying a Wounded Man
1812/23

Brush with brown ink and brown and gray wash over black chalk on ivory laid paper
205 × 145 mm (8⅛ × 5¾ in.)
Clarence Buckingham Collection, 1960.313

BOTH powerful and pathetic, this image of soldiers bearing a fallen comrade is probably a scene from the Peninsular War. It is thought to belong to one of eight known albums of Goya drawings, probably Album F, which contains many sepia drawings of violent, war-related subjects such as murder, execution, fighting, sickness, and deprivation. Similar in size and subject matter to this group of drawings, the sheet is a masterful characterization of human suffering. Burdened down, the hunched group progresses slowly through the shadows cast by an immense boulder. The wounded man, his face pale and drawn with pain, is set off from the others by the stark whiteness of the paper. The manner in which he is borne by his friends recalls the traditional iconography of the Deposition of Christ, possibly a deliberate reference by Goya to martyrdoms that went unnoticed during the war. Goya melded the supporting figures into a single entity, emphasizing their unity in a moment of sadness and tribulation.

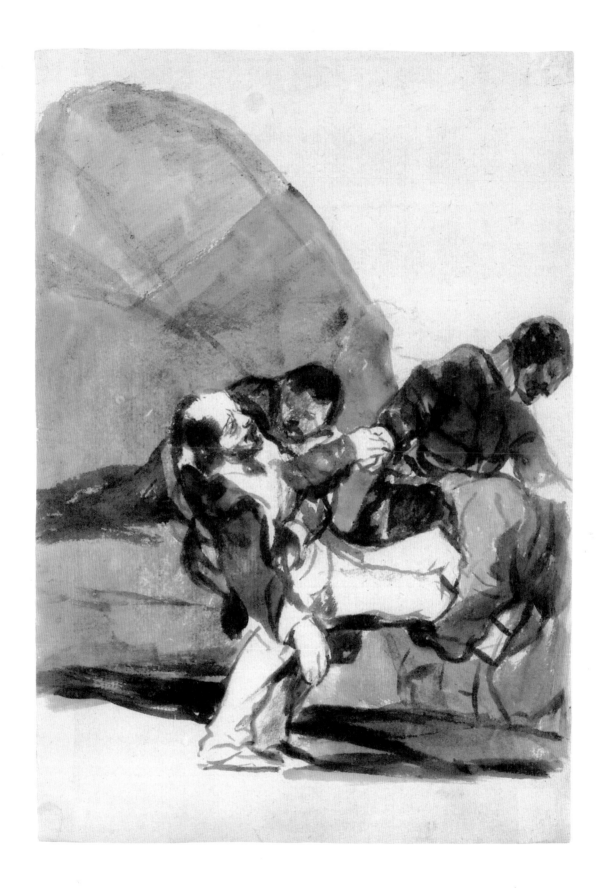

CATALOGUE NO. 51

Henry Fuseli

Swiss/English, 1741–1825

Portrait of a Woman (Marta Hess)
1781

Black and white chalk with touches of red on buff laid paper
434 × 315 mm (17⅛ × 12½ in.)
Inscribed recto, lower left, in black chalk: *Sept.ʳ 10. 81*
Clarence Buckingham Collection, 1971.310

ALTHOUGH Swiss by birth, Henry Fuseli settled in London as a student at the Royal Academy, where he was befriended by Sir Joshua Reynolds and remained to become professor of painting. Fuseli was as versatile a draftsman as he was prolific, leaving over eight hundred drawings that range in style from strict Neoclassicism to visionary fantasies that reflect his friendship with William Blake.

From 1779 to 1786, Fuseli made a number of studies of female heads such as this portrait of a woman which, in its soft manner and expression of entrancement, contrasts sharply with the artist's later stylized drawings of women's heads and coiffures. Traditionally the sitter has been identified as Marta Hess, one of the two sisters of the artist's friend Felix Hess. In 1779 Fuseli spent some time with the sisters in Ostende and drew their portraits. In the same year, Marta Hess died. Since the drawing is dated two years later, it would have to be a portrait made from memory. This seems somewhat unlikely, given the lifelike character of the face and the roughed-out pose of the sitter. However, Fuseli showed the young woman gazing upward, her large, transfixed eyes suggesting the fervent religiosity for which Marta Hess was known.

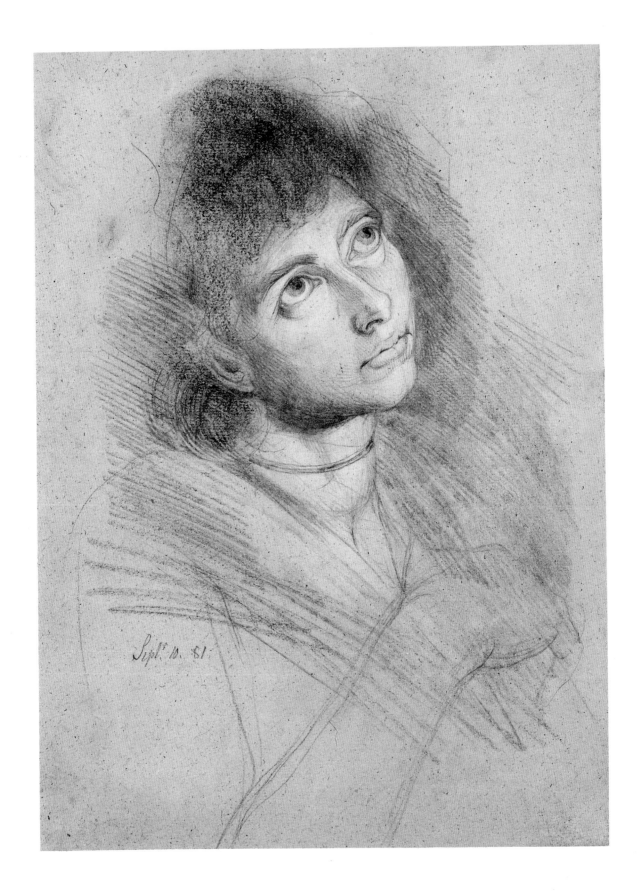

CATALOGUE NO. 52

Caspar David Friedrich

German, 1774–1840

Mountain Sanctuary

1804

Brush and gray wash over graphite on cream wove paper

244 × 382 mm (9⅝ × 15⅛ in.)

Inscribed recto: upper right, in graphite, *den 14t November 1804*; lower right, in an unknown hand, in pen and brown ink, *Friedrich. Dresd.*

Margaret Day Blake Collection, 1976.22

IN 1798, after a period of study in Copenhagen, Caspar David Friedrich settled in Dresden, which remained his home until his death in 1840. This landscape drawing, dated November 14, 1804, is from Friedrich's early years in Dresden. Subtly graded shades of gray wash evoke the gloomy, overcast days so common in Germany in November. Friedrich transformed the eerie Romantic landscape into a mountain sanctuary, with a statue of the Madonna at the summit. Barely visible at the foot of the statue, a diminutive figure of a pilgrim kneels in prayer. The drawing seems to be the earliest expression of the idea that came to fruition in the *Cross in the Mountains* (The Tetschen Altarpiece) of 1807–8, now in the Gemäldegalerie, Dresden.

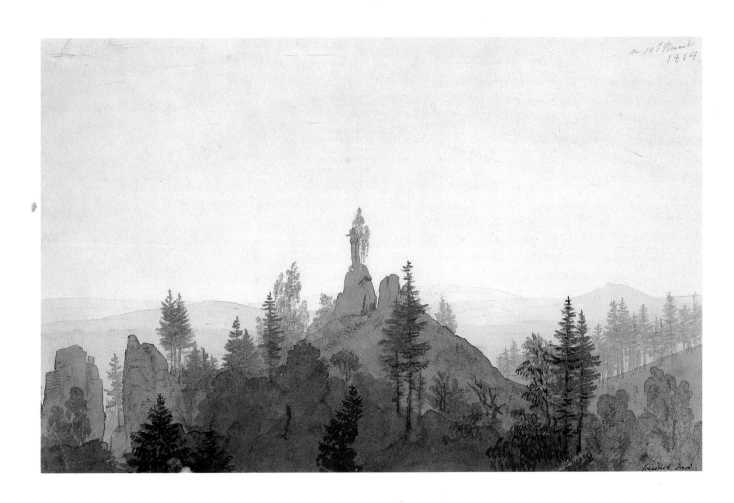

CATALOGUE NO. 53

Domenico Quaglio II

German, 1786–1837

Monk in the Ruins of a Monastery

1820s

Pen and black ink with brush and brown wash, squared in pencil for transfer, on ivory laid paper

313 × 405 mm (12⅜ × 16 in.)

Gift of Mr. and Mrs. Leigh B. Block, 1965.21

BORN into a prominent family of theatrical designers, Domenico Quaglio was himself a painter of architectural sets for the court theater in Munich. This drawing of a solitary monk gazing out across a misty landscape was probably made in the 1820s, a decade in which Quaglio traveled extensively, making sketches of ruins and churches. Within the Romantic tenor of the scene—the ruined building, encroaching nature, a lone, mysterious figure—Quaglio demonstrated his interest in the clear, crisp rendering of architectural elements. The sheet has been squared for transfer, suggesting that it was intended either for a larger project, such as a theatrical set, or perhaps as a study for a lithograph in one of Quaglio's two print series of the architecture—castles, battlements, churches, and ruins—of Bavaria.

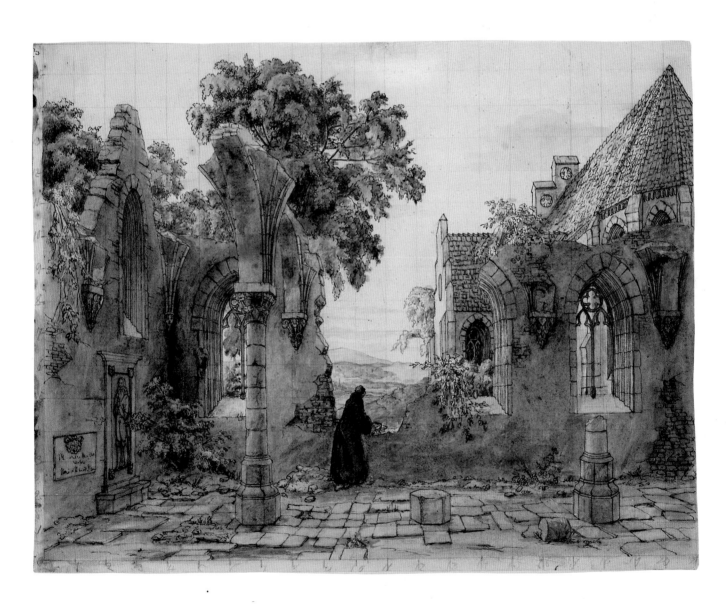

CATALOGUE NO. 54

Joseph Mallord William Turner

English, 1775–1851

View of Lucerne
1840/41

Watercolor, with white areas scratched into paper surface, on white wove paper

233 × 292 mm (9¼ × 11⁹⁄₁₆ in.)

Inscribed recto, lower right, in pen and brown ink, by John Ruskin: *I don't know the place/j Ruskin 1880/J M W T late time/and very bad for him*

Gift of Margaret Mower in memory of her mother, Elsa Durand Mower, 1960.10

JOSEPH Mallord William Turner began his career as a watercolorist and continued to work in this medium throughout his life. The rapid brushwork and heavy scraping of the paper in this watercolor help to place it in the period around 1840/41, when Turner was traveling and sketching in Switzerland. The view is almost certainly of Lucerne, despite the inscription at the lower right in the meticulous hand of John Ruskin, England's most influential nineteenth-century art critic, stating that he does not know the place. The confusion over the site—it occasionally has been identified as Geneva instead of Lucerne—derives from Turner's lack of attention to specific topographical characteristics of his motifs; instead, he devoted himself to demonstrating through the means of pure color the interactions of light, water, and atmosphere. In his late watercolors, such as this work, as well as in his oils of this period, Turner made a revolutionary step into the area between representation and abstraction.

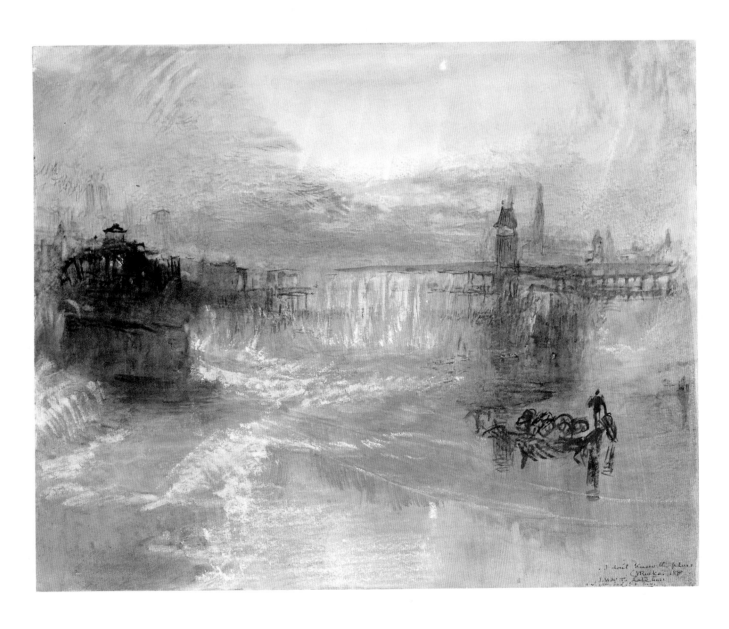

CATALOGUE NO. 55

Samuel Palmer

English, 1805–1881

A View from the North Downs near Sevenoaks
Early 1830s

Watercolor with black chalk on cream wove paper

246 × 365 mm (9¾ × 14⁷⁄₁₆ in.)

Inscribed recto, lower left, in pen and brown ink: *Near Sevenoaks/by Sam!*
Palmer

Gift of Mr. and Mrs. William O. Hunt, 1978.276

SAMUEL Palmer spent the early years of his career under the influence of the English visionary artist William Blake. His most original and creative period extended from 1827, the year of Blake's death, to 1835. During these years Palmer lived in the village of Shoreham in the county of Kent, where he devoted his attention to recording the hilly, picturesque countryside. The light, delicate palette evident in this drawing began to appear in Palmer's watercolors of the early 1830s. The mood of golden tranquility expresses Palmer's great fondness for this area, which he said was "as beautiful in its way as Italy."

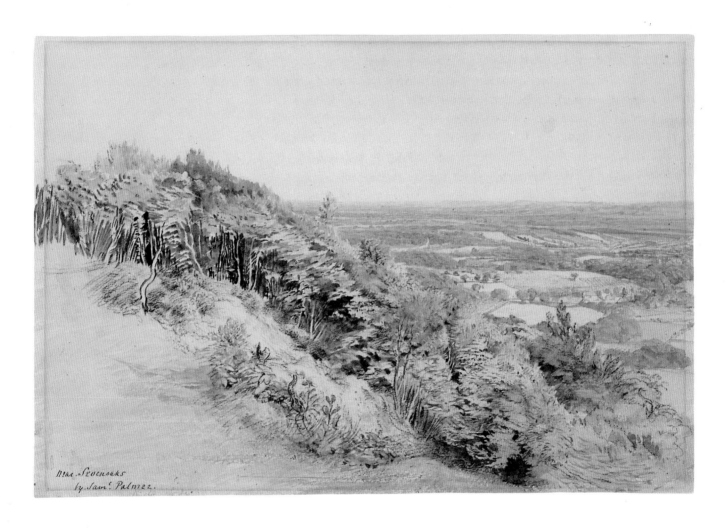

CATALOGUE NO. 56

Eugène Delacroix

French, 1798–1863

The Old Bridge at Mantes

1827

Watercolor over traces of black chalk on ivory laid paper

204 × 304 mm (8¹⁄₁₆ × 12 in.)

Olivia Shaler Swan Memorial Fund, 1963.392

THE leading painter of the Romantic movement in France, Eugène Delacroix was an ardent watercolorist who made numerous studies of the French countryside in the region of his country home at Champrosay. The poetic subject of this watercolor is the ruin of an old medieval bridge that stood on the left bank of the Seine in the town of Mantes. Delacroix is known to have sojourned in Mantes with his friend Charles Rivet in October 1827. The overcast sky and gray tones of the landscape indeed suggest a chilly day in mid-autumn. A related watercolor, formerly in the collection of the baron Vitta, is now in the Musée du Louvre, Paris. Another version by the artist of the same bridge is in the collection of Paul Brame, Paris.

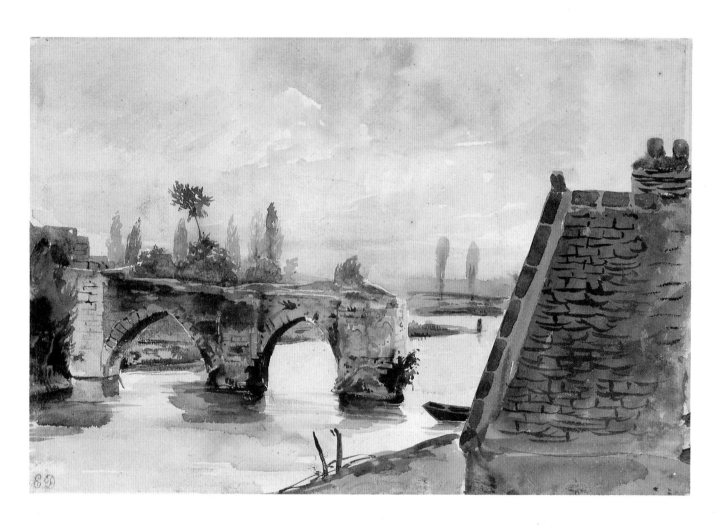

CATALOGUE NO. 57

Eugène Delacroix

Studies of Tigers and Other Sketches (recto)
1828/29

Graphite with pen and iron gall ink and watercolor on ivory laid paper
Sketches of Classical Coins and Medals (verso)
1825

Graphite with pen and iron gall ink

380 × 485 mm (15 × 19³⁄₁₆ in.)

David Adler Fund, 1971.309

IN this large, informal sheet, the sure, sweeping lines of
Delacroix's pen capture the very essence of the tiger. The large cat
is shown in a variety of poses, each clearly drawn from life. The
patches of watercolor on the left half of the sheet are samples in
preparation for some other work. The pencil and brush sketches of
men in sixteenth-century costume relate to Delacroix's painting
Cromwell at Windsor Castle of 1830, now in an unknown private
collection in England. The reverse side of the sheet bears a number
of tentative sketches of ancient coins which resemble lithographs
Delacroix made of the same subject in 1825. The animal studies, so
much bolder in execution, may be dated 1828 or 1829, when Delacroix
also produced the large lithograph *The Royal Tiger*. The subject of that
famous print and the colored tiger at the upper left of this drawing
crouch in the same lifelike position.

VERSO

130

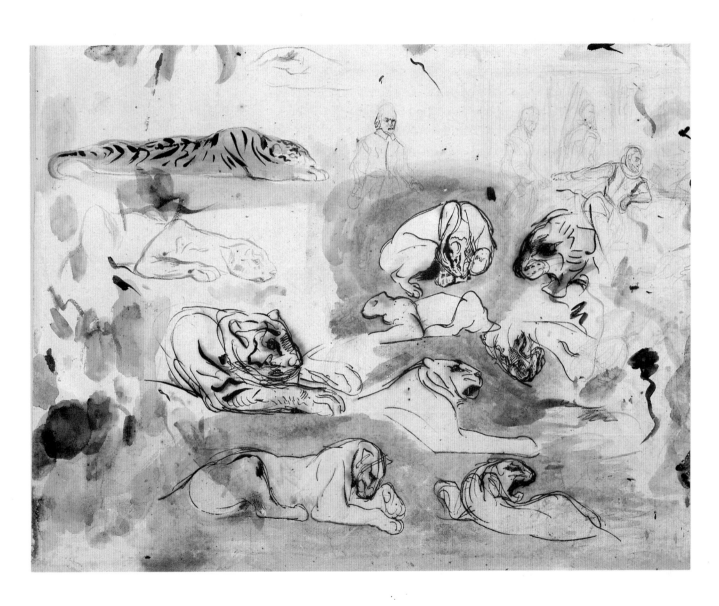

CATALOGUE NO. 58

Eugène Delacroix

Peasant Women of the Eaux-Bonnes
1845

Watercolor over graphite on ivory wove paper
339 × 260 mm (13⅜ × 10⁵⁄₁₆ in.)
Helen Regenstein Collection, 1981.1

I N the summer of 1845 Delacroix went to the Pyrenees to take the
waters at the spa of Eaux-Bonnes near the Spanish border. He was
delighted with the natural dignity of the local peasants and the
beauty of their colorful dress. In a letter of July to Frédéric Villot, he
wrote, "The natives, men and women, are far superior to the visitors:
their dress, the women's particularly, is charming. . . ." In this
watercolor, Delacroix clearly demonstrated his interest in the
costumes of two peasant women which, along with the Romantic
landscape behind them, gave him the opportunity to explore his
theory of complementary colors; he was fascinated especially by the
green shadows that he perceived in the color red. The unity of the
women with their mountainous homeland is conveyed through the
painterly and coloristic conception of the work, which in no way
obscures Delacroix's powerful draftsmanship.

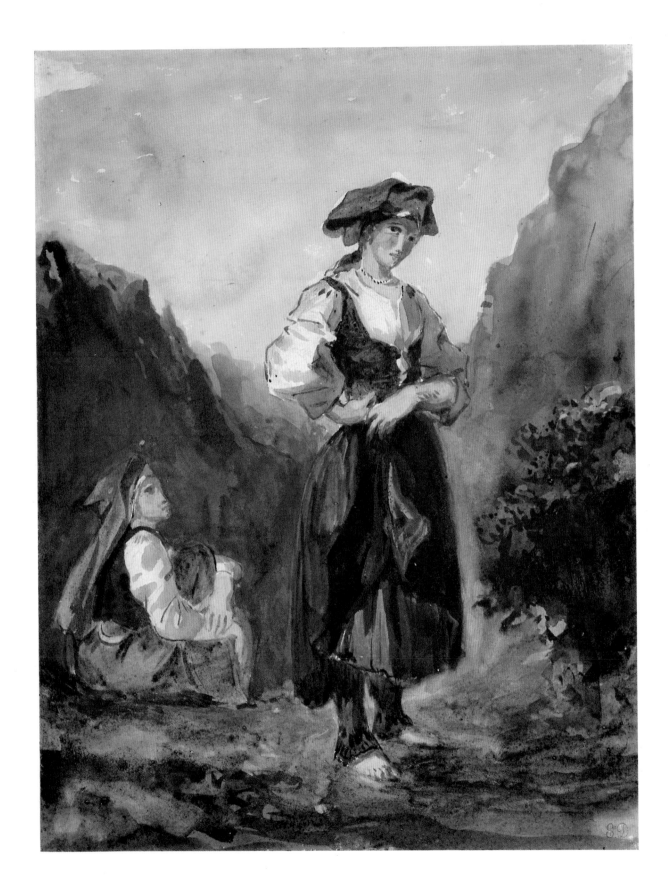

CATALOGUE NO. 59

Honoré Daumier

French, 1808–1879

Family Scene
c. 1865

Pen and black ink with brush and gray wash on ivory wove paper
214 × 205 mm (8½ × 8⅛ in.)
Inscribed recto, lower right, in pen and black ink: *h. D.*
Helen Regenstein Collection, 1965.633

BEST known for satirical lithographs that appeared in Parisian
political journals, Honoré Daumier was an artist who turned his
sharp wit to a variety of contemporary subjects. Thus, it is no
surprise that children are more often portrayed as nasty little
monsters than as a source of joy to their parents. This family scene is
one of the rare exceptions, showing a peaceful and idyllic relationship
among mother, father, and child. The nervous, quivering penwork
that builds the forms, and the illusion of a sunny landscape achieved
by a minimum of lines, suggest a date around 1865, based on
comparison with lithographs Daumier was producing at that time.

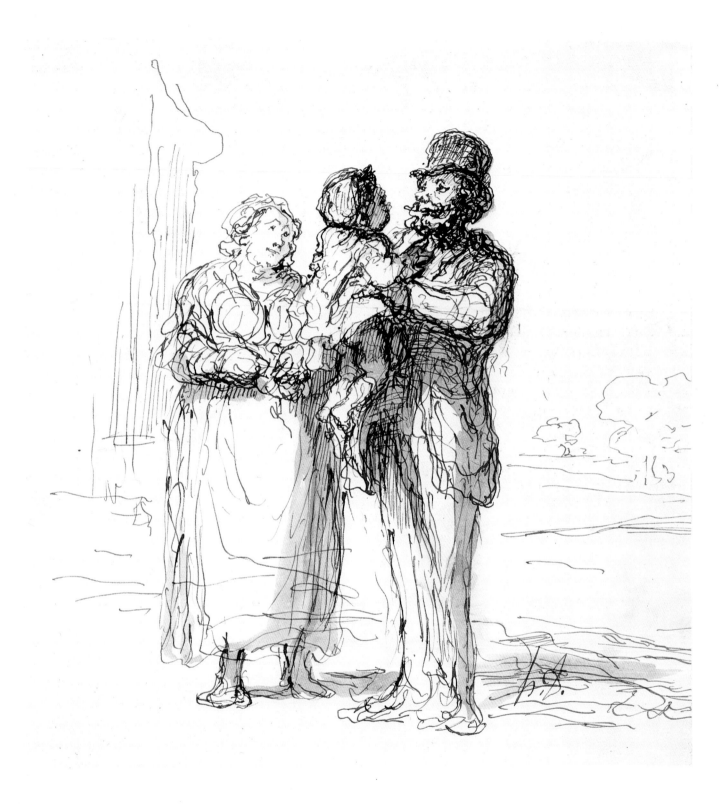

CATALOGUE NO. 60

Honoré Daumier

The Three Connoisseurs
After 1869

Pen and black ink with gray and brown wash over traces of charcoal on ivory wove paper
493 × 392 mm (19⁹⁄₁₆ × 15½ in.)
Inscribed recto, lower right, in graphite: *N 19*
Gift of Mrs. Helen Regenstein in honor of Frank B. Hubachek, 1968.1

DAUMIER'S wit frequently was leveled at social mores. The passionate collector of pictures, seen either enjoying his own private treasures or peering intently at possible "bargains" in auction houses, was one of Daumier's favorite themes, particularly in the 1860s. This large and brilliant wash drawing focuses on three collectors in a vast hall, probably at an auction preview in the Hôtel des Ventes, Paris. Although Daumier almost never dated his paintings, drawings, or watercolors, this sheet can be dated quite accurately after 1869 by the watermark in the paper, which reads: J. WHATMAN/TURKEY MILLS/1869. A painting closely related to this drawing (Collection Mrs. Harris Jonas, New York) has been dated to between 1858 and 1862. The fact that the drawing postdates the painting by at least ten years shows how Daumier often returned to certain subjects. A splendid work from the last decade of the artist's life, this sheet is especially appealing for its spacious ambiance.

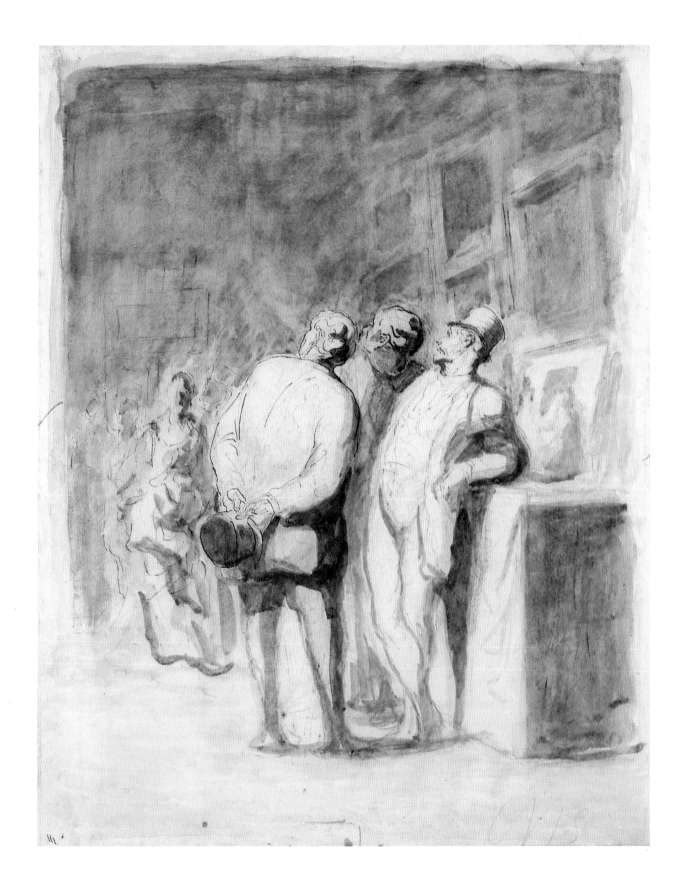

CATALOGUE NO. 61

Gustave Courbet

French, 1819–1877

Seated Model Reading in the Studio
1845/47

Charcoal, with white areas scraped into paper surface, on ivory wove paper
562 × 390 mm (22¼ × 15⁷⁄₁₆ in.)
Inscribed recto, lower left, in charcoal: *G. Courbet*.
Simeon B. Williams Fund, 1968.163

A rebel who rejected both Classicism and Romanticism in favor of a realist style and subject matter, Gustave Courbet was one of the most influential artists of the nineteenth century. His drawings communicate the same love of naturalistic detail that made his paintings revolutionary—even shocking—to his more traditional contemporaries. The young model who posed for this drawing seems to be the same girl depicted in several other works by Courbet, among them *The Sleeping Bather* of 1845 (The Detroit Institute of Arts) and *The Sleeper* of 1847 (Musée du Louvre, Paris). It is on this basis, as well as on stylistic grounds, that the sheet may be dated to between 1845 and 1847. Here, the model is seen at rest, in between poses in an artist's studio. The large piece of sculpture behind her suggests that it may be the atelier of a sculptor. The girl wears a smock and has a thin veil over her shoulders. Her striped dress and ruffled bow lie discarded on a nearby chair—the same chair, incidentally, that appears in a drawing entitled *Courbet before His Easel* (Fogg Art Museum, Harvard University, Cambridge, Massachusetts).

Courbet was by no means a draftsman in the academic sense, and the handling of the medium in the present sheet is quite unconventional; many of the white highlights have actually been scratched with *estompe* into the surface of the paper. The drawing, a finished work in its own right, also reveals something of Courbet's genius as a painter, particularly in the soft modeling of the forms, the convincing sense of texture, and the tangible atmosphere of the studio.

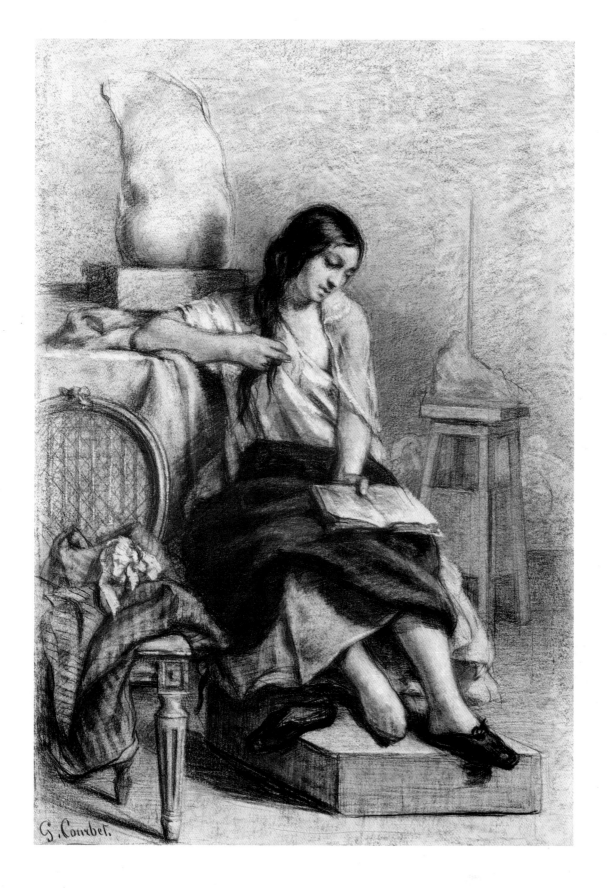

CATALOGUE NO. 62

Jean-Baptiste Carpeaux

French, 1827–1875

Study for Ugolino and His Sons
1860

Pen and brown ink with gray and white gouache over traces of black chalk on brown wove paper

622 × 480 mm (24⁹⁄₁₆ × 19 in.)

Inscribed recto, in pen and brown ink: lower right on base of statue, *J Bte Carpeaux 1860*; lower left on base of statue, *que mia urta venenata/Io piango, sospiro, treno./riposare me! . . . Ecco! Ecco la mia m . . . !!!!! Sono matto.*

Helen Regenstein Collection, 1963.264

AS winner of the Prix de Rome, Jean-Baptiste Carpeaux was a resident student at the French Academy in Rome between 1856 and 1862. There he was deeply impressed by the sculpture of Michelangelo and by Hellenistic statuary, such as the renowned Laocoön group. In the face of the Academy's conservative restrictions regarding subject matter, the artist sought financial backing for the execution of *Ugolino and His Sons*, a multifigural sculpture of the story of Count Ugolino, told by Dante in the *Inferno* (canto 33). Ugolino, who had been arrested for treason and imprisoned in a tower to starve to death, devoured his sons and grandsons. This drawing for the sculpture reveals Carpeaux as a draftsman of great power and originality. It probably depicts the maquette that Carpeaux took to Paris, where it won the support of the minister of state, Achille Fould. The model for the sculpture was completed in 1861, acquired by the state, and finally cast in bronze; the sculpture established Carpeaux's fame.

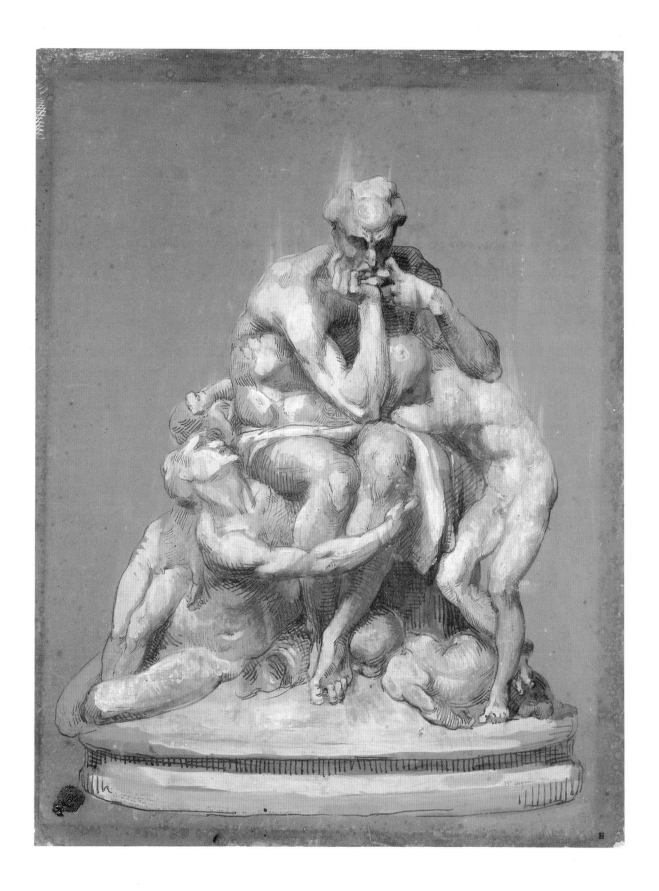

CATALOGUE NO. 63

Gustave Moreau

French, 1826–1898

Portrait of Eugène Lacheurie

1852

Graphite on ivory wove paper

323 × 245 mm (12¾ × 9¹¹⁄₁₆ in.)

Inscribed recto, center right, in pencil: *à Madame Lacheurie,/Gustave Moreau/1852*

Helen Regenstein Collection, 1982.1

GUSTAVE Moreau, whose reputation was founded primarily on his elaborate depictions of biblical and mythological themes (see cat. no. 65), demonstrated a considerable aptitude for portraiture in his youth. The composer Eugène Lacheurie, a friend of the young Moreau, is pictured here in a relaxed and easy pose. Another friend of the same period was the artist Théodore Chassériau, who was certainly a major inspiration to Moreau in his production of delicate pencil portraits in 1852–53. Chassériau himself was making fine graphite portraits in the manner of his great teacher, Jean-Auguste-Dominique Ingres (see cat. nos. 48, 49). Moreau's accomplished likenesses of friends and family members were modeled on the drawings of Chassériau, even to the extent of inscribing the sheet at the right in the same way, with a wavy line below the inscription. His portraits of this period are characterized by a sure, accurate line. As in this drawing, the head of the sitter is generally quite finished, while the body is rather sketchy by comparison.

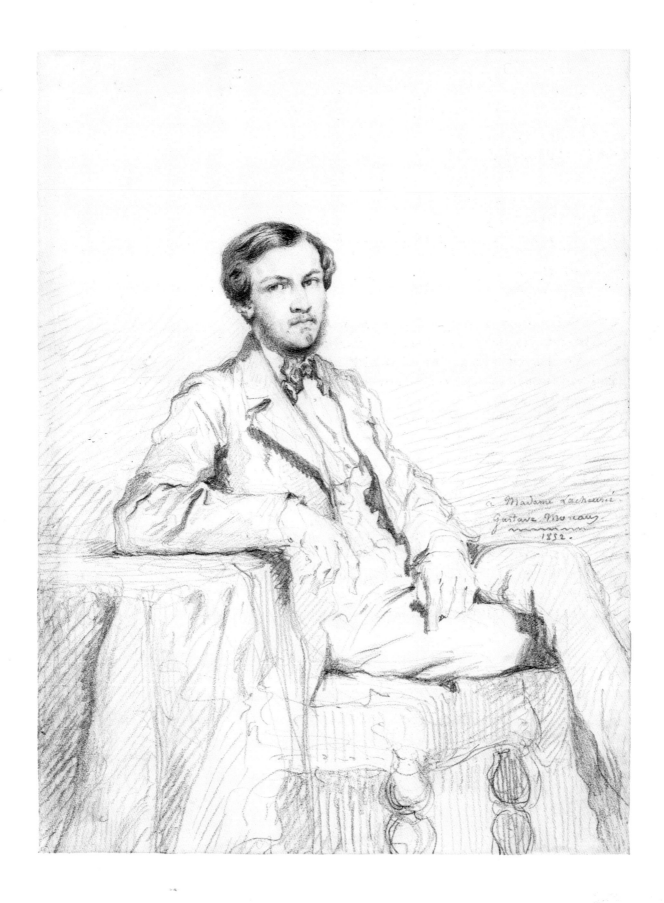

CATALOGUE NO. 64

Gustave Moreau

Hercules and the Hydra of Lerna
1876

Pen and brown ink with brush and brown wash over black chalk, heightened with white gouache, on white laid paper

183 × 152 mm (7¼ × 6 in.)

Inscribed recto, in pen and brown ink: lower right, *Gustave Moreau*; lower left, *L'Hydre*

Helen Regenstein Collection, 1983.281

T HE several large paintings that Moreau exhibited at the Salon of 1876 brought him to the attention of Parisian critics. One of these canvases, *Hercules and the Hydra of Lerna*, was shown again at the Paris World's Fair of 1878. Since 1964 it has been part of the permanent collection of The Art Institute of Chicago, where it was joined in 1983 by this exquisite, finished preparatory drawing. Although several other versions of the composition exist in the Musée Gustave Moreau in Paris, this sheet is considered the most final and complete study for the painting.

Moreau was attracted to the Hercules myth by the element of confrontation that is inherent in each of the labors of the great hero. It is said that at one time he considered painting all twelve labors, but finished by treating only the second one, the slaying of the Lernaean Hydra. This feat involved a gruesome battle with a deadly nine-headed serpent who grew two new heads each time one was severed. Rather than depicting the two foes locked in battle, Moreau selected the tense moment before the eruption of violence. The young, athletic Hercules, illuminated by a divine light that prophesies his victory, stands alert and controlled, ready for the slightest aggressive movement from the Hydra. Below them lies the pale body of the Hydra's latest victim—a death soon to be avenged.

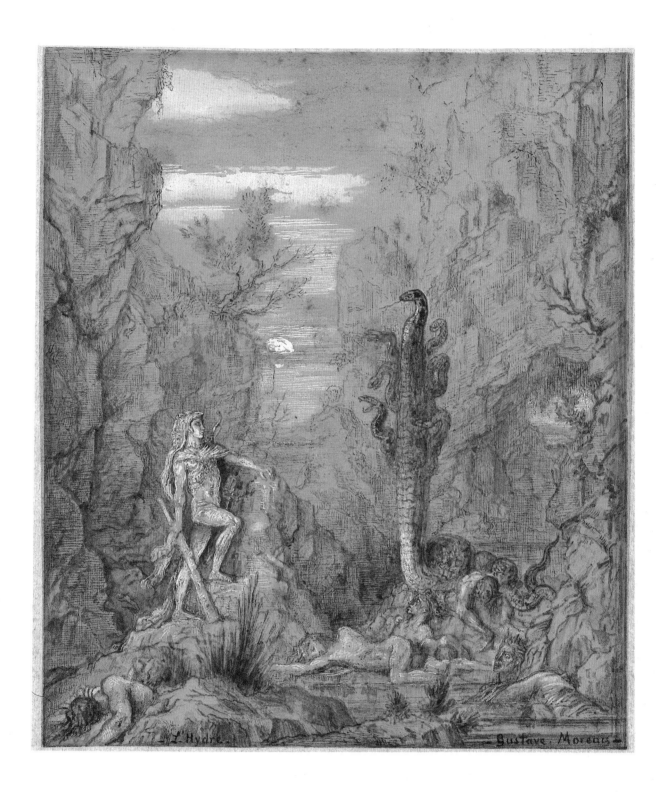

CATALOGUE NO. 65

Edouard Manet

French, 1832–1883

Study of a Seated Nude (The Toilette)
c. 1862

Red chalk on ivory laid paper
280 × 200 mm (11$\frac{1}{16}$ × 7$\frac{15}{16}$ in.)
Inscribed recto, lower right, in graphite: *E. Manet*
Helen Regenstein Collection, 1967.30

AS Rembrandt's late nude studies had in his day, the figure drawings of Edouard Manet exasperated contemporary critics by their disregard for "correct" academic method and their lack of concern for classical anatomy and proportion. Manet drew from a painter's point of view and, as in his canvases, his technique was based on the opposition of light and shadow, with as little intermediary tone as possible. A fine example is this free, rapid study of light playing over a soft female body. Although unrelated to any known painting in Manet's oeuvre, the drawing may be a preparatory sketch for an etching entitled *The Toilette*, published in 1862. Another drawing related to that project exists in the Courtauld Institute Galleries, London. The sitter for both drawings appears to be Manet's model Victorine Meurend. The mysterious attendants in the background have been blocked in roughly with bold contours and heavy crosshatching, adding a slightly ominous tone to the scene.

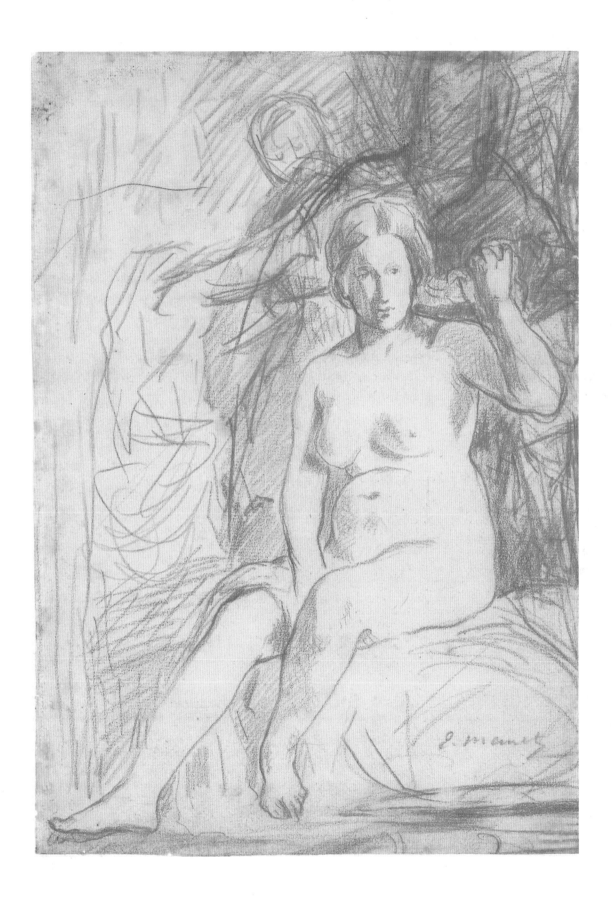

CATALOGUE NO. 66

Edouard Manet

Portrait of Berthe Morisot
1874

Watercolor on ivory wove paper
205 × 165 mm (8⅛ × 6⁹⁄₁₆ in.)
Helen Regenstein Collection, 1963.812

THE sensitive features and dark-eyed beauty of the painter Berthe Morisot caught the attention of Manet for the first time in 1868 when the two artists were introduced by Henri Fantin-Latour. In the next five years, she appeared frequently in Manet's work: in ten paintings, two lithographs, and an etching. She is the principal figure in *The Balcony* of 1868 (Musée d'Orsay, Paris).

Nowhere have the lively charm and enchanting expression of Berthe Morisot been better captured than in this delicate watercolor. It is probably a preliminary study for the last painting Manet made of her, in the autumn of 1874, just before her marriage to his younger brother Eugène. Although the final painting (owned by the Rouart family in Paris) is somber and somewhat reserved in tone, the watercolor is enchantingly fresh and spontaneous. Morisot's animated features and nervously poised hand suggest lively conversation, in spite of the black shawl she wears as a sign of mourning for her father, who had died in January.

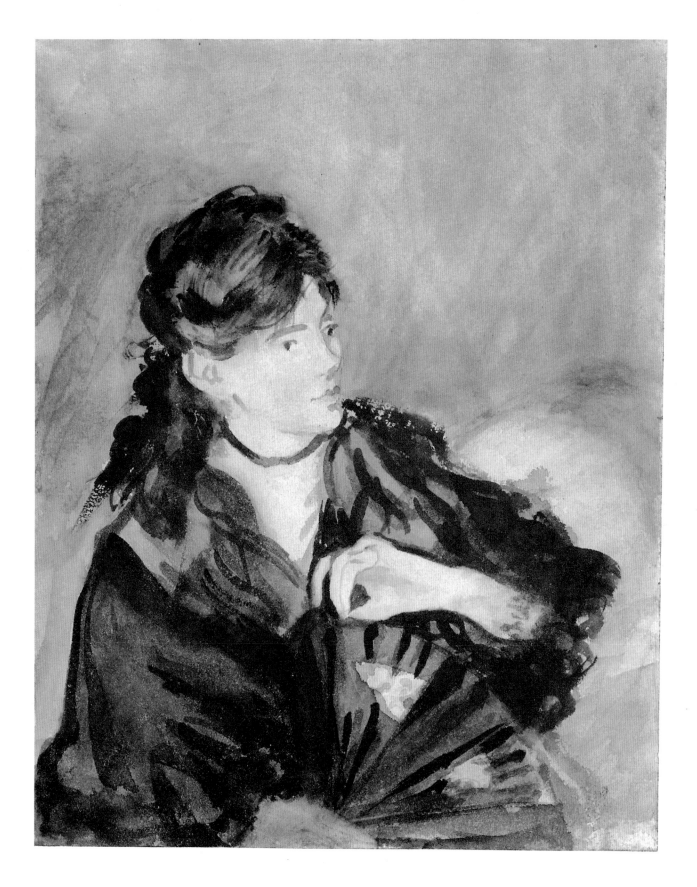

CATALOGUE NO. 67

Henri Fantin-Latour

French, 1836–1904

Portrait of Edouard Manet

c. 1880

Lithographic crayon on ivory wove paper

400 × 312 mm (15¹³⁄₁₆ × 12⅜ in.)

Inscribed recto: lower left, in lithographic crayon, *A mon ami Manet/ Fantin*; lower right, in graphite, *A Aristide Albert/son serviteur fidèle/Léon Leenhoff*

Clarence Buckingham Collection, 1967.595

ALTHOUGH he exhibited regularly at the official Salon, Henri Fantin-Latour was friendly with many of the avant-garde artists of his day. In 1867, when he painted the famous portrait of his friend Edouard Manet (now in The Art Institute of Chicago), he did full justice to the handsome and elegant appearance of the great painter. The composition of this masterful drawing is identical with that of the painting; even the wording of the inscription is the same except for the omission of the date. It was drawn as a souvenir of the painting to accompany an article by Gustave Goetschy devoted to Manet at the time of the exhibition of his paintings and pastels at the galleries of *La Vie Moderne*. The style of the drawing—its controlled and very finished appearance—is characteristic of the drawings Fantin made after paintings for reproduction in the illustrated press.

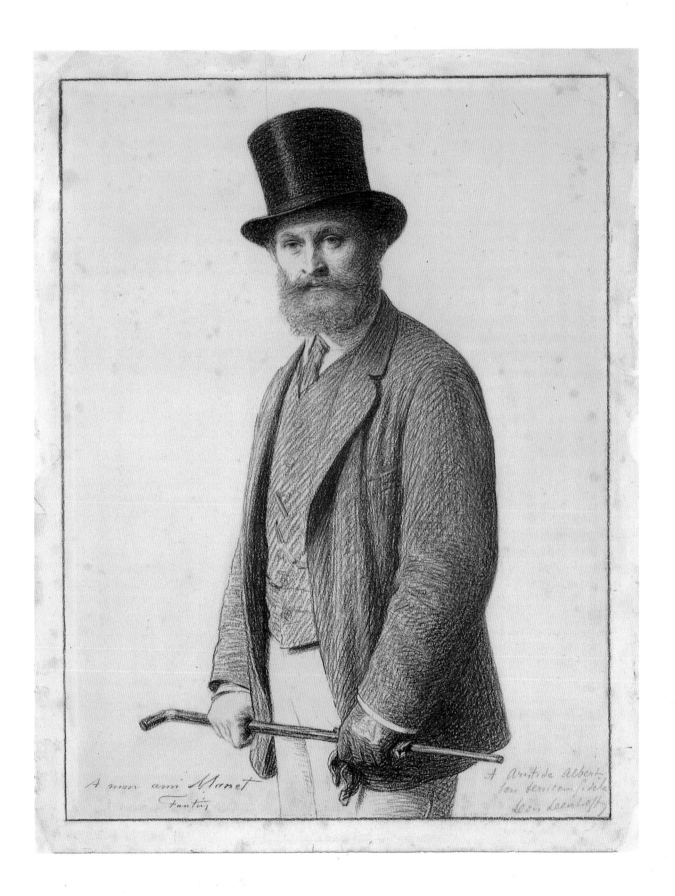

CATALOGUE NO. 68

Odilon Redon

French, 1840–1916

Landscape with a Large Oak
1868

Charcoal with *estompe* on buff wove paper
535 × 755 mm (21⅛ × 29¹⁵⁄₁₆ in.)
Inscribed recto, lower left, in charcoal: *od. Redon/68*
Ada Turnbull Hertle Fund, 1966.349

MEMORIES of his lonely childhood on an isolated estate at Peyrelebade continued to haunt Odilon Redon throughout his career and to contribute to his artistic vision. In later life, recalling his early years there, he wrote, "Yes, an ancient wall, an old tree, a certain horizon can be nourishment and a vital element for an artist—there, where he has his roots" (a note of 1910; published in *Redon/Moreau/Bresdin* [New York, 1961], p. 11). Such sentiments, as well as remembrances of the work of his friend and teacher Rodolphe Bresdin, are apparent in this great, dark, Romantic landscape. The magnificent spreading oak that dominates the scene was probably drawn from nature; a simpler, and undoubtedly later, drawing of the same tree is owned by the artist's son, Arï. With extensive use of *estompe* to manipulate the charcoal, Redon created here the dramatic lighting effects of an approaching thunderstorm. The two figures on a rock to the right of the tree, although too small to be identified, may be Virgil and Dante, who so often appear in the artist's early landscapes. Redon made a present of this drawing to his mother.

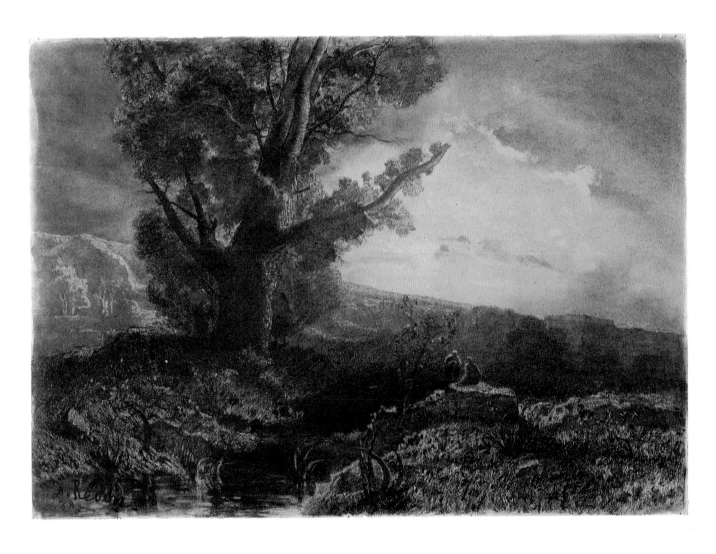

CATALOGUE NO. 69

Odilon Redon

Dawn of the Last Day

c. 1880/85

Pastel, charcoal, and gouache on buff wove paper

410 × 388 mm (16³⁄₁₆ × 15⅜ in.)

Inscribed recto, lower right, in charcoal: ODILON REDON

Gift of Margaret Day Blake Collection, Mr. and Mrs. Henry C. Woods, and William McCallin McKee Memorial Funds, 1982.87

REDON's favorite color, which he used exclusively for many years at mid-career, was black; as a result, he made a great many of his drawings in charcoal. Nevertheless, he was an artist capable of achieving the most brilliant and unusual color effects. In this drawing Redon combined pastel, charcoal, and gouache to express a whole range of color, from rich blacks to the glowing tones of the sun, applied with short strokes of bright pastel. Redon, always full of lyrical and mystical visions, evoked here an especially mysterious dream landscape. The lone, silhouetted figure of a woman appears almost to be chiseled from the craggy mountaintop on which she is seated. A very similar drawing, entitled *Setting Sun*, is in the Claude Roger-Marx Collection, Paris.

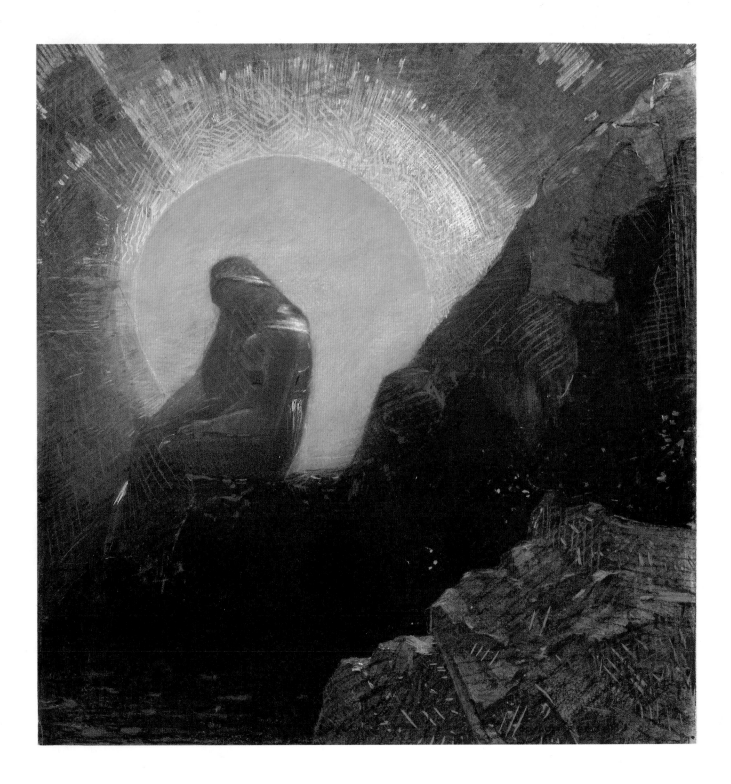

CATALOGUE NO. 70

Pierre-Auguste Renoir

French, 1841–1919

Portrait of Edmond Renoir

1881

Conté crayon with pen and black ink on ivory laid paper

380 × 285 mm (15 × 11¼ in.)

Inscribed recto, lower left, in brush and black ink: *Renoir*

Helen Regenstein Collection, 1977.491

AN Impressionist known for his use of vivid, sensuous color applied with bold, rhythmic brushstrokes, Auguste Renoir also was capable of a surprisingly precise linear style in his black-and-white drawings. Renoir began earning his living in the early 1870s by painting portraits, and portraiture remained one of his favorite art forms throughout his career. The artist's younger brother Edmond posed for this portrait in the garden of the hotel where the two brothers stayed at Menton, on the Côte d'Azur, in 1881. A charming example of their close relationship and frequent collaboration, the drawing was made to illustrate an article entitled "L'Etiquette," written by Edmond, a journalist, for the December 15, 1883, issue of *La Vie Moderne,* a periodical to which many of the Impressionists contributed drawings.

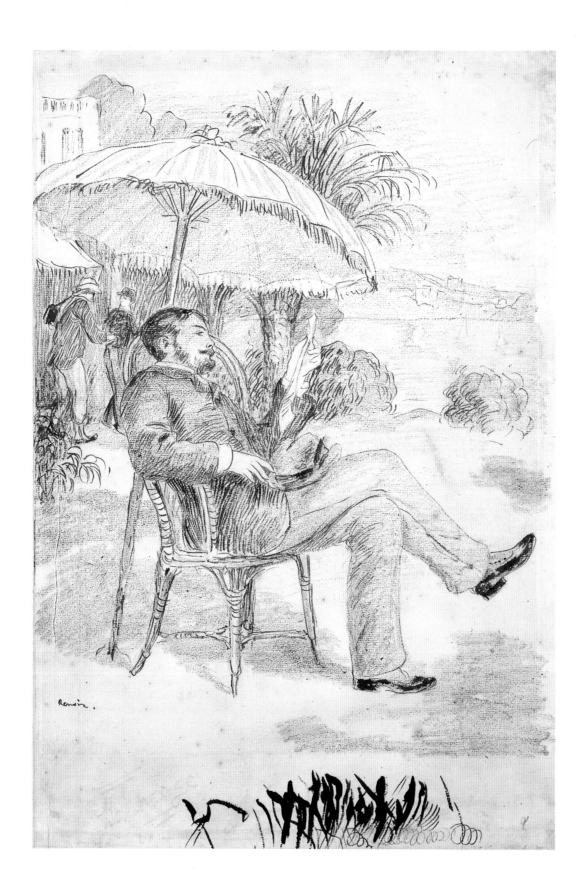

CATALOGUE NO. 71

Paul Gauguin

French, 1848–1903

Still Life with Cat
1899

Watercolor on ivory wove paper
632 × 360 mm (24⅞ × 14⅛ in.)
Inscribed recto, upper right, in pencil: *P. Gauguin*
Gift of Helen Tieken Geraghty in memory of Mr. and Mrs. Theodore Tieken, 1981.409

ALTHOUGH he exhibited his work with the Impressionists during the years 1880 to 1886, Paul Gauguin was an extremely independent artist who never was completely at home with the traditions of Western naturalism. His interest in exotic subject matter and non-Western cultures led him to Martinique in 1887, to Tahiti in 1891, and there again permanently in 1895. A late watercolor, *Still Life with Cat* is a celebration of color, flat patterns, and exuberant brushwork giving no hint of the depression and illness that Gauguin suffered in these last years of his life, and which led him to attempt suicide in 1898. Yet the sheet can be dated securely to the year 1899 on the basis of its similarity to a signed and dated painting entitled *Still Life with Cats* (Ny Carlsberg Glyptothek, Copenhagen), in which one of the cats is virtually identical with the mysterious feline crouched in the foreground of this watercolor.

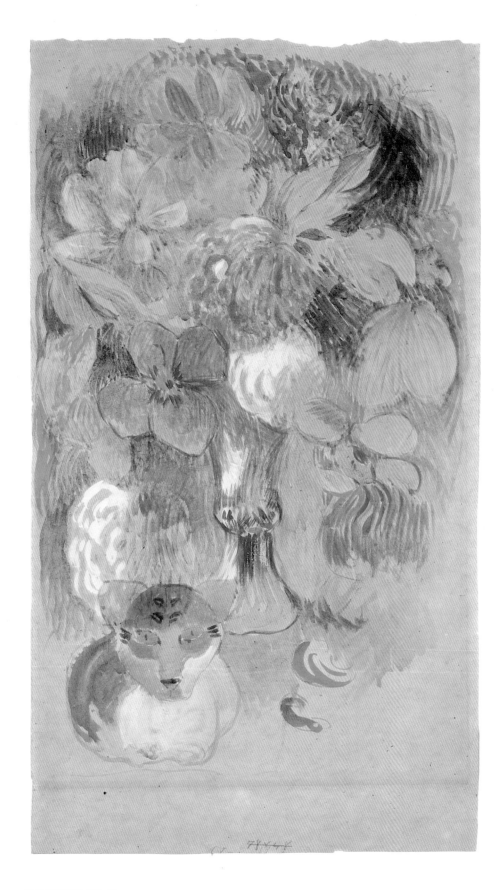

CATALOGUE NO. 72

Paul Cézanne

French, 1839–1906

Peasant with a Straw Hat
1905/6

Watercolor over graphite on white wove paper
480 × 315 mm (19 × 12½ in.)
Gift of Janis Palmer in memory of Pauline K. Palmer, 1983.1498

A great master of portrait and landscape painting, Paul Cézanne made surprisingly few outdoor portraits. It was not until his move to Chemin des Lauves, near Aix, in 1902, that he began to pose his sitters out of doors. There he took advantage of the terrace in front of his studio, with the garden in the background, to make a series of open-air portraits. In this splendid watercolor from the last year of his life, Cézanne transformed a formal composition into a playground of clear, dazzling color. A peasant seated frontally in a chair is set against a background of foliage; the scene is dappled with sunlight. Rapid, brilliantly colored brushstrokes modulate the forms without defining them concretely. Cézanne allowed the white of the paper to remain in certain areas, enhancing the sense of light playing over surfaces.

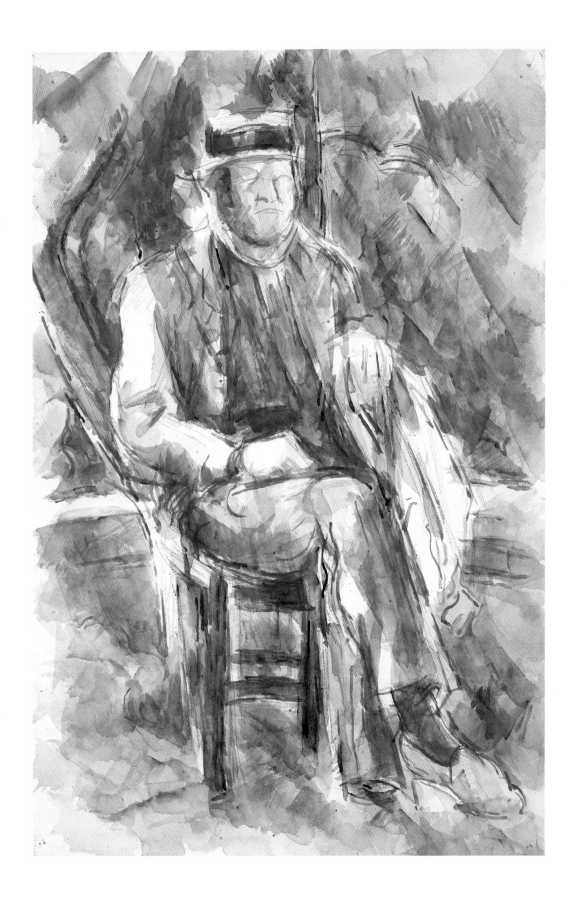

CATALOGUE NO. 73

James Ensor

Belgian, 1860–1949

Portrait of the Artist's Sister Marie
1881

Charcoal on ivory wove paper
755 × 595 mm (29¹⁵⁄₁₆ × 23½ in.)

Inscribed recto, lower left, in charcoal: *Portrait de Mlle. Marie Ensor/Ensor/1881*

Margaret Day Blake Collection, 1970.42

DESTINED to become a startlingly original painter-printmaker, whose sensitivity to social and political issues was often expressed in grotesque imagery and caricature, James Ensor left the provincial environment of his native Ostend at the age of seventeen to study at the Académie Royale des Beaux-Arts in Brussels. Soon tiring of the stultified atmosphere of "that establishment for the near blind" (as he called it), Ensor became one of the founding members of Les XX, a group of antiestablishment artists, writers, and musicians.

In 1880 Ensor moved back to Ostend, setting up his studio in his family home. The household seems to have been an unhappy one; the gloom and tension of his domestic situation are communicated plainly in the artist's many drawings from this period. His most frequent model was his younger sister, Marie, nicknamed Mitche. This large charcoal portrait of Mitche reading suggests the stillness and oppressiveness of the house and its effect on the unstable Marie, who was the model for Ensor's painting of 1882 titled *The Distressed Woman*. The strong sense of mood and atmosphere, as well as the accomplished manipulation of the charcoal, reveals Ensor to have been a draftsman of sophistication and sensitivity, even though he was only twenty-one years old.

CATALOGUE NO. 74

Vincent van Gogh

Dutch, 1853–1890

Landscape with Pollard Willows
1884

Pen and brown ink over graphite on ivory laid paper
340 × 440 mm (13⁷⁄₁₆ × 17³⁄₈ in.)
Robert Allerton Fund, 1969.268

ADMIRED today as one of the most individual of the Post-Impressionist artists, Vincent van Gogh decided to become a painter in 1880, just ten years before his premature death. Although plagued during his brief career by poor mental and physical health, he was immensely productive and left a vast oeuvre of paintings and graphic work. He began his artistic career in Holland where, after short stays in Enten, the Hague, and Drenthe, he settled in his parents' home in Neunen. There, despite a tense and unhappy relationship with his father, he made great strides as a painter and draftsman. His favored subjects in this period were the local weavers at work and the countryside surrounding his home. *Landscape with Pollard Willows* is one of the wintry landscapes that van Gogh depicted in March 1884, according to his letters. His fascination with the spiky, animated pollard trees and with the stubbly vegetation covering the terrain is most suitably conveyed by the wiry hatchings of the pen over graphite. The radiating winter sun, a motif recurrent in later works, appears for the first time in this drawing. A small, bent figure, barely discernible among the reeds in the middle distance, serves as a reminder of van Gogh's sympathetic interest in the local workers.

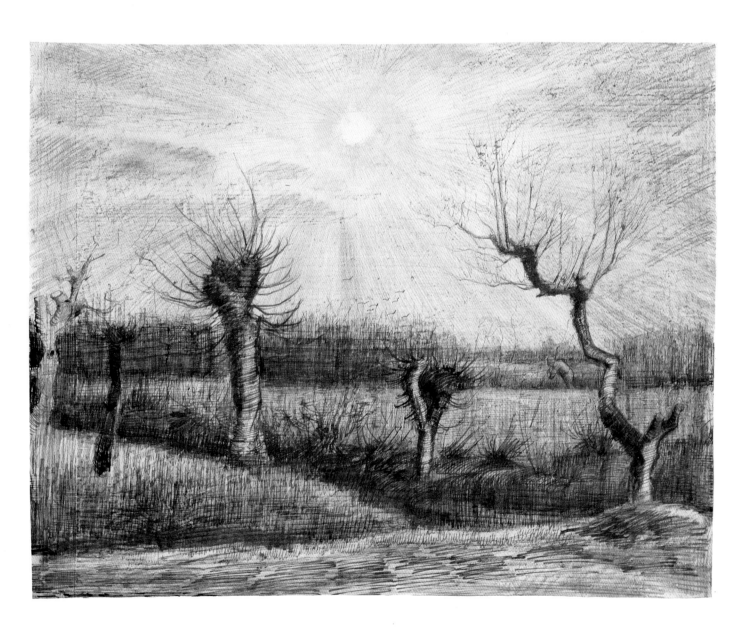

CATALOGUE NO. 75

Georges Seurat

French, 1859–1891

Landscape with Trees
1884

Conté crayon on white laid paper
619 × 470 mm (24⅟₁₆ × 18⁹⁄₁₆ in.)
Helen Regenstein Collection, 1966.184

AMONG the most intellectual artists of his generation, Georges Seurat evolved optical color theories and an interest in strict, formal compositions that were extremely influential for a group of artists who came to be known as the Neo-Impressionists. He developed a technique of painting called Divisionism, which involved the application of pure color in small, regularly spaced dots of pigment. Seurat's masterpiece, *A Sunday Afternoon on the Island of La Grande Jatte* of 1884–86, in The Art Institute of Chicago, is a consummate demonstration of his new ideas. His conté crayon studies for the painting are not theoretical exercises, but evocative, sophisticated sheets that function as independent works of art. Numerous figure studies are known, but drawings for the terrain itself are far rarer. In this large, luminous drawing, the wide range of delicate tonalities suggests a light mist rising off the water. The sinuous tree in the foreground seems nearly human. The mood is one of quiet, gentle communion with nature—an elusive aura that was not transferred to the painting.

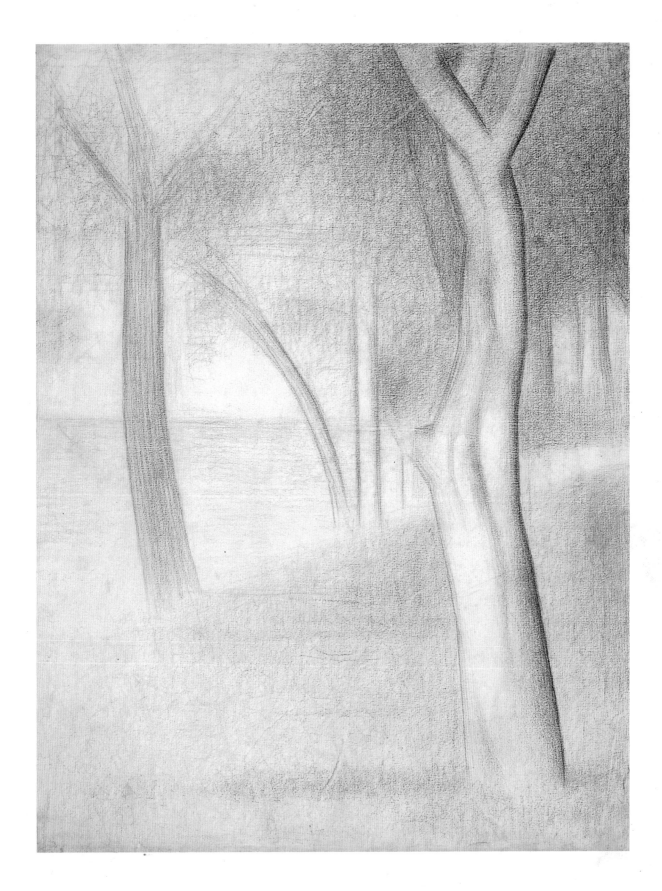

CATALOGUE NO. 76

Henri de Toulouse-Lautrec

French, 1864–1901

At the Circus: Work in the Ring
1899

Colored pencil with pastel and black crayon on ivory wove paper
218 × 316 mm (8⅝ × 12½ in.)
Inscribed recto, lower left, in black crayon: *T–Lautrec*
Gift of Mr. and Mrs. B. E. Bensinger, 1972.1167

A N artist with a wide technical range at his disposal, Henri de
Toulouse-Lautrec was a prolific painter, draftsman, and
lithographer. He was influenced strongly both in subject matter and
method by Edgar Degas; Lautrec's compositions, characterized by
unusual viewpoints, reflect the admiration for photography and
Japanese prints that was so pervasive in Impressionist circles. *At the
Circus: Work in the Ring* is one of about thirty-nine drawings of circus
subjects that Lautrec made between February and May 1899, while
recuperating from the effects of alcoholism in a sanitarium at Neuilly.
The artist's letters of these months indicate that he suffered a great
deal from his lack of freedom. Works from memory, recollections of a
happier time, the circus drawings seem to have been a vehicle for
letting loose his imagination and forgetting the gloom of his situation.
A finished, painterly drawing, *Work in the Ring* demonstrates
Lautrec's genius for suggesting movement through the freedom and
rapidity of his handling. The sweeping curve of the ring, the
distorted viewpoint of the spectator, and the compositional tension
set up between the powerful, galloping horse and the bright,
diminutive ringmaster all contribute to a sense of exhilarating speed.

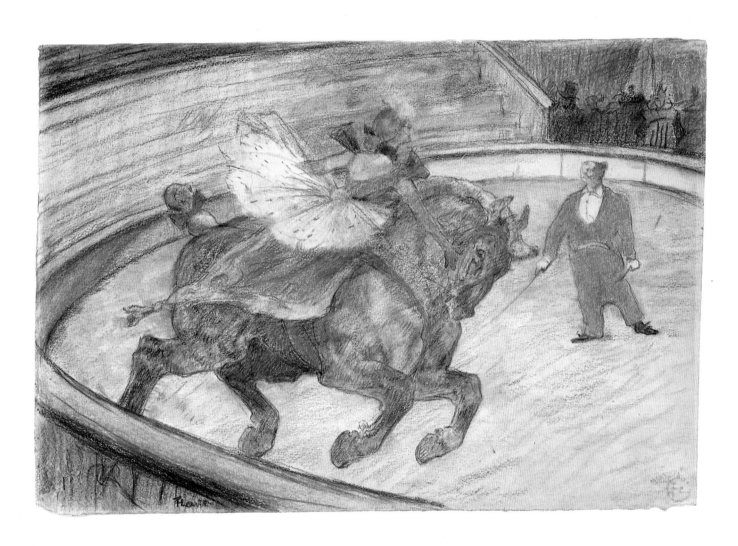

CATALOGUE NO. 77

Henri de Toulouse-Lautrec

Mademoiselle Cocyte
1900

Red chalk and graphite, heightened with white chalk, on ivory wove paper
350 × 255 mm (13⅞ × 10⅛ in.)
Inscribed recto, lower left, in red chalk: *T–Lautrec*
Helen Regenstein Collection, 1965.146

TOULOUSE-Lautrec's vivid portrayals of Parisian dance halls, nightclubs, and brothels suggest the enormous vitality of the city but also reflect the dissipated lifestyle that hastened the end of the artist's tragically short career. In a vain attempt to recover his health in a more provincial setting, the artist spent the last winter of his life in Bordeaux. There he discovered with delight the opera house and the unabashedly vulgar and vivacious Mademoiselle Cocyte, singer of the title role in Offenbach's *La Belle Hélène*. Lautrec made a number of rapid sketches of her, of which this one is most successful in capturing her animated stage presence and sensuality. With a few meaningful, highly simplified lines, he conveyed movement, expression, and the spirited atmosphere of the scene. The sheet is an extraordinary example of the mastery of the artist's late drawing style.

CATALOGUE NO. 78

Winslow Homer

American, 1836–1910

The Water Fan

1898/99

Watercolor over pencil on white wove paper

372 × 533 mm (14¾ × 21¹⁄₁₆ in.)

Inscribed recto, lower right, in watercolor: *Homer*

Gift of Dorothy A., John A., Jr., and Christopher Holabird in memory of William and Mary Holabird, 1972.190

THROUGH the honesty and realism of his style, Winslow Homer revolutionized American painting in the late nineteenth century. His acknowledged place as leader of the American school brought him honors, although little in the way of financial success. Always a solitary man, Homer became increasingly reclusive in his later years. He spent his summers in Maine; by the 1890s he was spending each winter in Florida and the Bahamas. In both places he pursued his interest in capturing the many moods of the sea. His superb watercolors display his sensitivity to the qualities of light and color peculiar to each of the locations in which he worked. While the Maine subjects are often somber and cool in tone, the Bahamian watercolors are full of brilliant, dazzling color. *The Water Fan* is a magnificent example of Homer's broad, direct handling of the medium, which is not dissimilar to the frankness of the Impressionists. His delight in the daily lives of the local people, whose existence was linked so inextricably to the sea, is suggested here as well. A stalwart young man, adrift in a small boat on a turquoise sea, harvests coral in his bucket. The title of the work is derived from the large, fanlike piece of coral which is seen in the boat behind him.

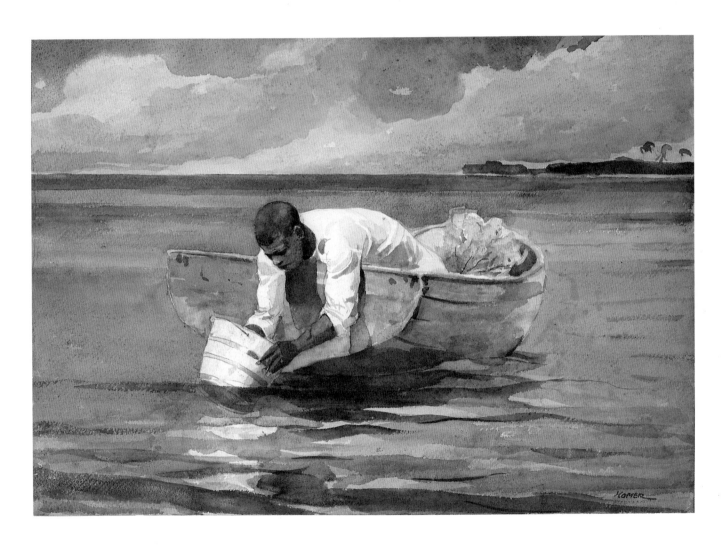

CATALOGUE NO. 79

Käthe Kollwitz

German, 1867–1945

Self-Portrait

c. 1891/92

Pen and black ink with brush and gray wash, heightened with white gouache, on brown wove paper

400 × 320 mm (15¹³⁄₁₆ × 12¹¹⁄₁₆ in.)

Inscribed recto, lower right, in pencil: *Käthe Kollwitz*

Gift of Margaret Day Blake, Mr. and Mrs. Alan Press, and Prints and Drawings Purchase, 1980.361

BEST known for her moving depictions of the effects of poverty and despair on the common man, the German artist Käthe Kollwitz began her artistic training under an engraver in her native Königsberg. Later she studied in a women's art school in Berlin where, although she was anxious to paint, a teacher urged her to "stick to drawing." In these early years she developed a sensitivity to drawing and printmaking that would remain with her throughout her career; her works in both mediums are always closely interrelated.

This melancholy, contemplative self-portrait, one of more than fifty probing images of herself that she produced in her lifetime, is clearly linked in style, composition, and mood to the etched self-portraits of 1892–93. Although this sheet is an independent work of art, Kollwitz's drawings often served as preliminary studies for prints. While this portrait is rendered largely in a loose black ink wash, the face and hands are illuminated in white gouache, which has been applied in a series of tight, methodical hatchings similar to those used in etching.

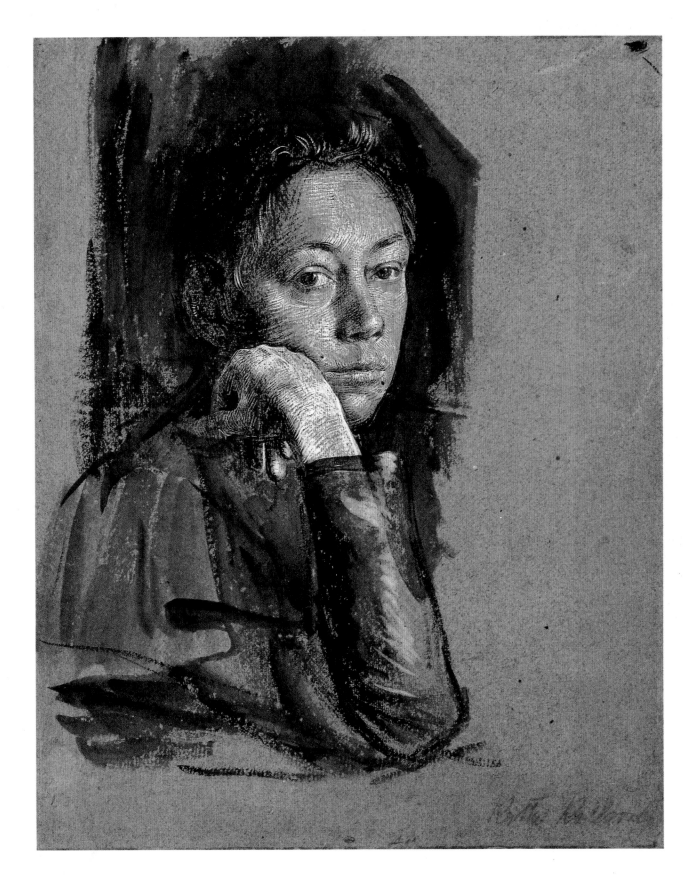

CATALOGUE NO. 80

Paula Modersohn-Becker

German, 1876–1907

Portrait of a Peasant Woman
1900

Charcoal on buff wove paper
433 × 639 mm (17⅛ × 25¼ in.)
Inscribed recto, lower right, in charcoal: *Paula Modersohn-Becker*
Gift of the Donnelley Family, 1978.26

PAULA Modersohn-Becker is today considered to be one of the leading artists of her day and an important precursor of the German Expressionist style. Following her training in Berlin (1896–98), she settled in an artists' colony in the small town of Worpswede, near Bremen. There, under the influence of the rustic setting and colleagues who stressed the importance of working directly from nature, her drawings and paintings became dominated by local peasant subjects. This portrait of a peasant woman displays the simple, realistic style that is characteristic of her work in this period, just before her influential trip to Paris in 1900, when she became acquainted with the art of van Gogh and Gauguin. Despite their unrelenting naturalism and apparent coarseness, Modersohn-Becker's peasant portraits are icons of a dignified, if harsh, way of life.

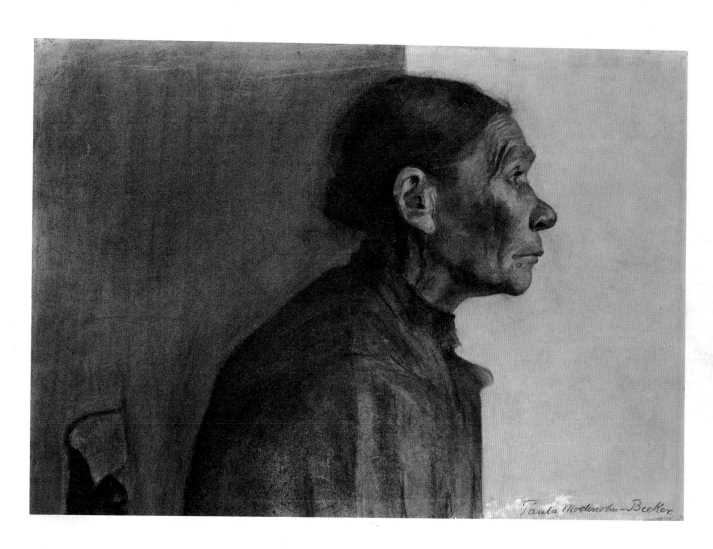

CATALOGUE NO. 81

Henri Matisse

French, 1869–1954

Portrait of a Young Woman (Elsa Glaser)
1914

Pencil on ivory wove paper
285 × 227 mm (11¼ × 9 in.)
Inscribed recto, lower left, in pencil: *Henri Matisse 1914*
Margaret Day Blake Collection, 1964.1

THE principal artist of the Fauve movement, Henri Matisse went on to become one of the greatest artists of the twentieth century. The bright, raw colors and bold shapes of his Fauve period gave way in the early years of World War I to an austerity of structure, line, and color. The rather severe execution of this pencil drawing, one in a large series of portraits that Matisse produced between 1912 and 1916, is characteristic of this wartime seriousness, yet anticipates the few portraits he was later to make in the Cubist manner. Here Matisse already demonstrated his interest in reducing forms to their geometric relationships. The sitter, Elsa Glaser, was the wife of Curt Glaser, a curator who arranged for the exhibition of Matisse's work in Berlin in July 1914. During the negotiations for the exhibition, Matisse visited the Glasers' home, where he admired their substantial collection of prints by the Norwegian artist Edvard Munch. When Matisse drew this portrait of Elsa Glaser, he may have purposely invested her with a little of the distant, yet alluring demeanor of the women that populate Munch's secret world.

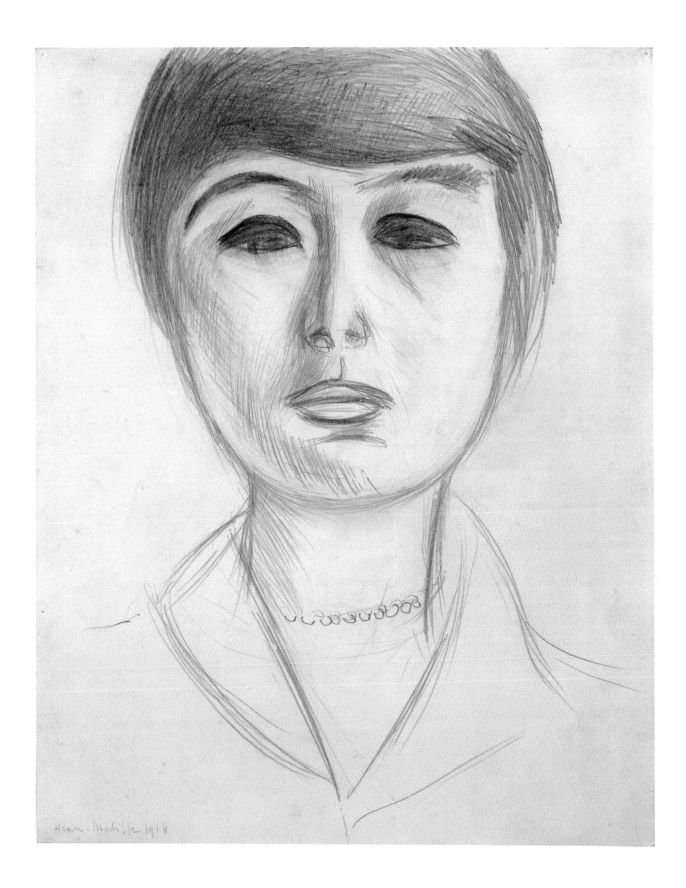

CATALOGUE NO. 82

Umberto Boccioni

Italian, 1882–1916

Head of a Woman (Ines)
1909

Pencil on ivory wove paper
382 × 394 mm (15⅛ × 15⁹⁄₁₆ in.)
Inscribed recto, lower right, in pencil: *Boccioni 1909*
Margaret Day Blake Collection, 1967.244

DESPITE his untimely death at the age of thirty-three, Umberto Boccioni was the leading sculptor—as well as a pivotal founding member—of the Italian Futurists, who attempted to capture the dynamism of the modern machine age. Between 1907 and 1910, before Futurism was formalized into an actual movement, Boccioni produced a number of graphite portraits of friends and family such as this one of his longtime mistress, Ines, which marks a transitional point in his evolution as a draftsman. In this drawing Boccioni already was demonstrating what would become a Futurist belief: that all things—figures and machines alike—are in constant motion even when they seem inactive. Ines's carefully delineated hair appears to move sensuously; the geometrical structure of the face is activated by shifting planes; her eyes look out from this sculptural visage with a disturbingly lifelike penetration.

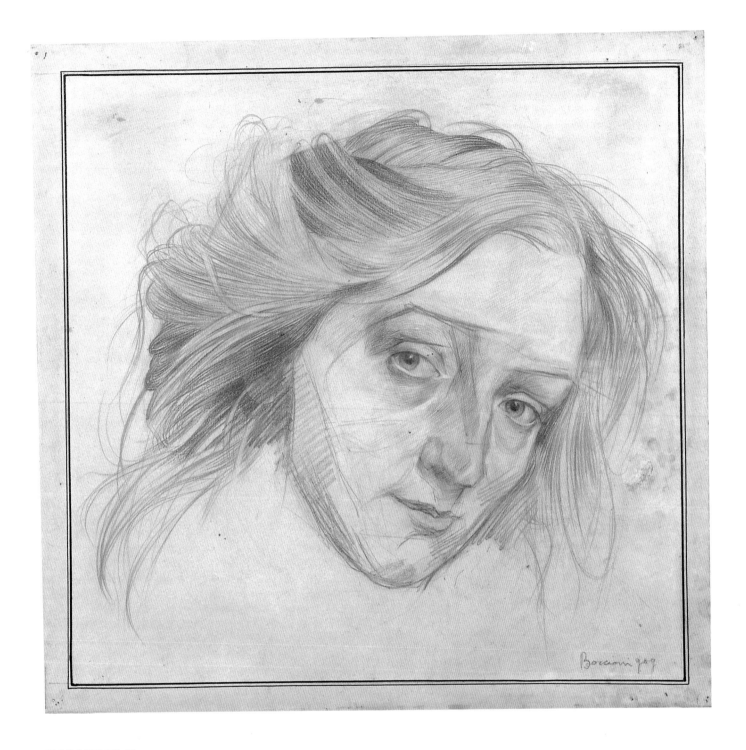

CATALOGUE NO. 83

Gino Severini

Italian, 1883–1966

Still Life with Box of Matches
1912

Charcoal, white chalk, and collage on buff wove paper
497 × 622 mm (19⅝ × 24⁹⁄₁₆ in.)
Inscribed recto, lower right, in charcoal: *G. Severini 1912*
Joseph Winterbotham Fund and Gifts of Curt Valentin and Mrs. Henry C. Woods, 1974.377

ALLIED with the Futurists and influenced at various times in his career by Georges Seurat and the Neo-Impressionists, Cubism, and Italian Renaissance painting, Gino Severini was an open-minded, inquiring artist who never committed himself completely to a single school or style. He settled in Paris in 1906, but continued to spend many of his summers in Italy. It was probably in Pienza in the summer of 1912 that he produced this landmark *Still Life with Box of Matches*, his first use of collage and, indeed, one of the very first creations anywhere to employ this medium. Here Severini took a monumental step in juxtaposing real and drawn objects. The color and crisp outlines of the real matchbox provide a sharp contrast to the muted, subtle tones of the charcoal drawing. Nevertheless, the matchbox is not altogether out of place in a tabletop still life that includes a Chianti bottle, decanter, and glasses. This drawing was the first in a series of such Cubist collage still lifes that Severini made between 1912 and 1914.

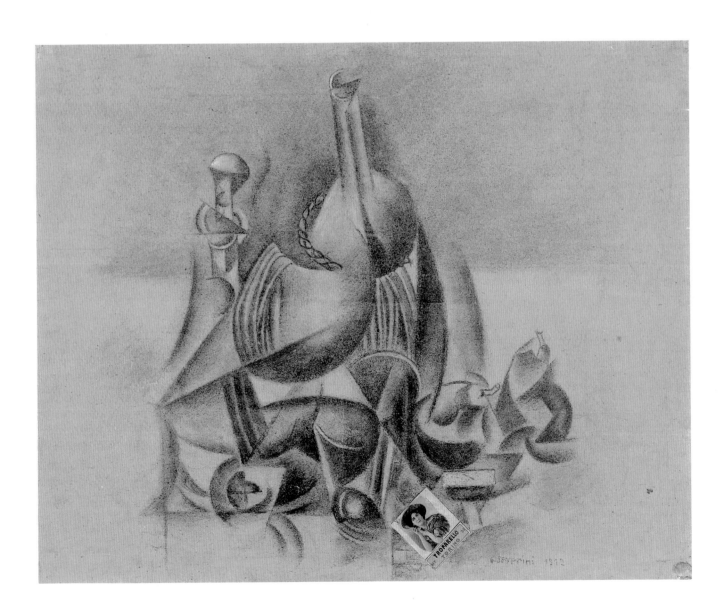

CATALOGUE NO. 84

Ernst Ludwig Kirchner

German, 1880–1938

Two Nudes
1905

Colored chalk on cream wove paper
624 × 892 mm (24⅝ × 35¼ in.)
Inscribed recto, lower right, in pencil: *E L Kirchner 05*
Albert Kunstadter Family Fund, 1963.557

ERNST Ludwig Kirchner was twenty-five years old when he made this majestic drawing entitled *Two Nudes*. That year, 1905, was a crucial moment in his artistic development: in July he received a degree in architecture from the Technisches Hochschule in Dresden; he discovered and was greatly influenced by the primitive sculpture in the Dresden ethnology museum; and, with fellow students Fritz Bleyl, Erich Heckel, and Karl Schmidt-Rottluff, he founded Die Brücke (The Bridge). The artists of Die Brücke, inspired by Edvard Munch, Vincent van Gogh, and Henri Matisse, were instrumental in promoting the growth of modern Expressionism. The impact of Matisse and the Fauves is especially apparent in *Two Nudes*. Startling contrasts of pure color are applied with varied—sometimes insistent, sometimes decorative—strokes of the chalk, creating a flickering and radiantly dynamic surface.

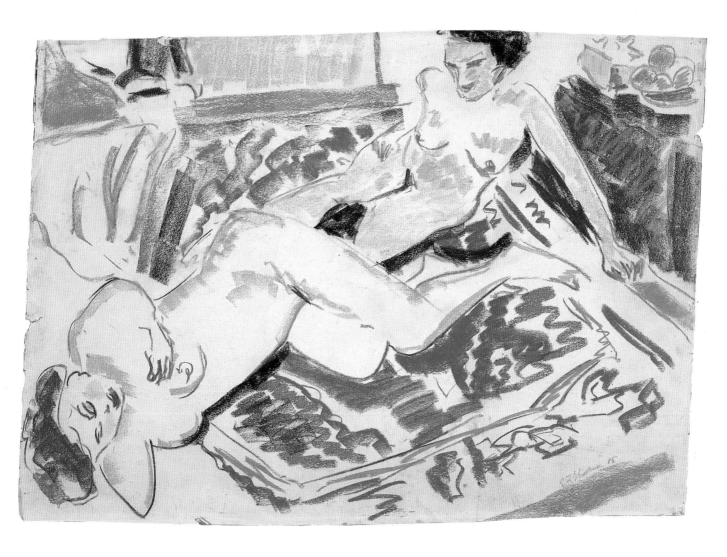

CATALOGUE NO. 85

Ernst Ludwig Kirchner

Two Women
1912

Charcoal and pastel on cream wove paper
622 × 455 mm (24⁹⁄₁₆ × 18 in.)
Inscribed recto, lower right, in pencil: *E L Kirchner 12*
Gift of Mr. and Mrs. Stanley M. Freehling, 1981.390

IN 1912, a year before the Brücke group disbanded, Kirchner was working in an aggressive, more overtly Expressionist style. In *Two Women* harsh, forceful rhythms dominate the image, expressing the inner tensions that the artist perceived in his subject and, indeed, in his world. Kirchner deliberately used his medium in a jarring and coarse fashion here in order to give the drawing an unstudied and spontaneous character; the use of vivid, unexpected colors contributes to the overall sense of nervous excitement.

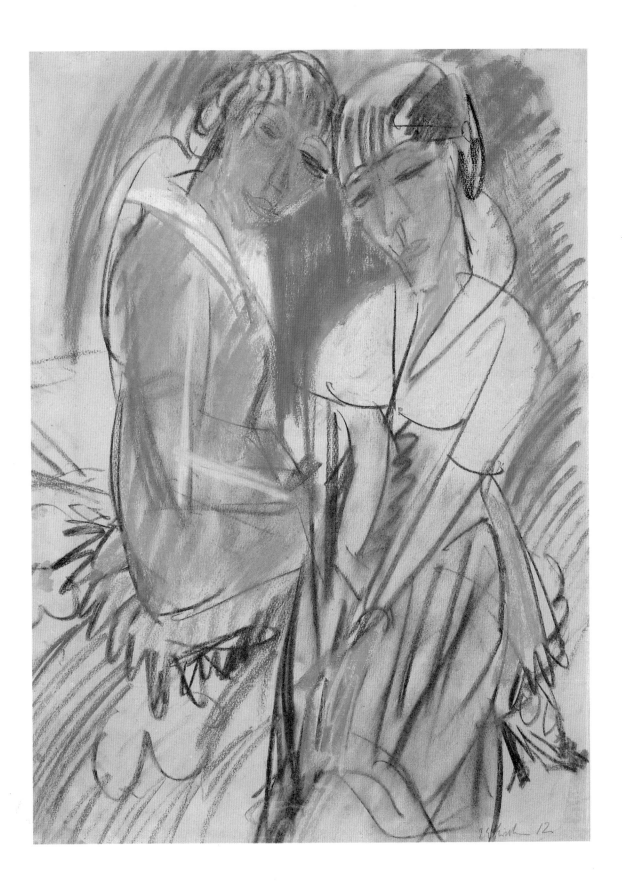

CATALOGUE NO. 86

Max Beckmann

German, 1884–1950

Self-Portrait
1917

Pen and black ink on ivory laid paper
389 × 317 mm (15⅜ × 12⁹⁄₁₆ in.)

Inscribed recto, upper right, in black ink: *Beckmann/Mitte März des Gluchlichen/Jahres 1917/in der Nacht um 4 Uhr fruh*

Gift of Mr. and Mrs. Allan Frumkin, 1975.1127

ONE of the leading German Expressionist painters, Max Beckmann was labeled "decadent and degenerate" by the Nazi party. In 1937 he immigrated to Holland, and later to the United States, where he lived until his death in 1950. His work reflects the trauma and terror of the World War I period in Europe; even many years later Beckmann's imagery contains strong references to the despair of that time. According to the inscription that Beckmann added in the upper right corner, this brooding self-portrait was drawn at four o'clock in the morning. The face of the artist, cradled in his right hand, is that of a man tormented: the rapid play of the pen across the paper suggests the anxious state of his temperament. The depressed mood he succeeded in communicating—primarily through the deep-set, blankly staring eyes—is strangely quiet and contemplative in contrast to his electric handling of the medium. It is the image of an emotionally exhausted man, confronting himself full face in the hours just before dawn.

188

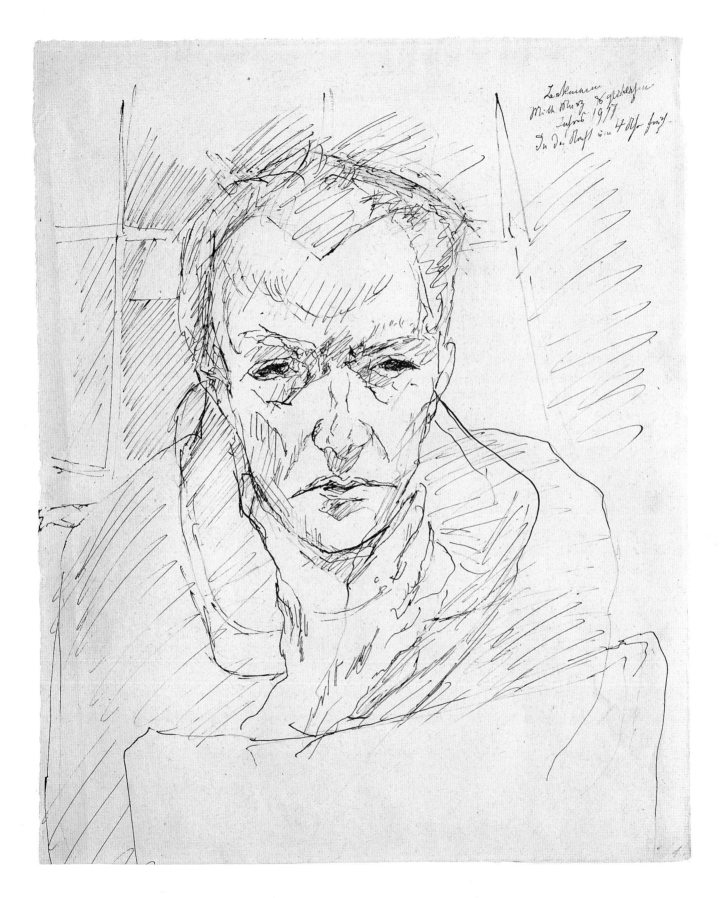

CATALOGUE NO. 87

Max Beckmann

The Bathers
1928

Black and white chalk on blue wove paper
870 × 580 mm (34⅜ × 22¹⁵⁄₁₆ in.)
Inscribed recto, lower right, in black ink: *Beckmann/Scheveningen 28*
Gift of Mr. and Mrs. Stanley M. Freehling, 1964.202

*T*HE *Bathers* is one of the few works by Max Beckmann that apparently is devoid of symbolic overtones. It is a scene of athletic group activity, drawn on the beach at the famous Dutch seaside resort of Scheveningen. Robust vacationers are shown cavorting in the water, splashing and playing games. Despite the lighthearted theme, the composition is constructed of large, solid figures whose powerful diagonals and strong black contours invest the scene with a quality of sober monumentality.

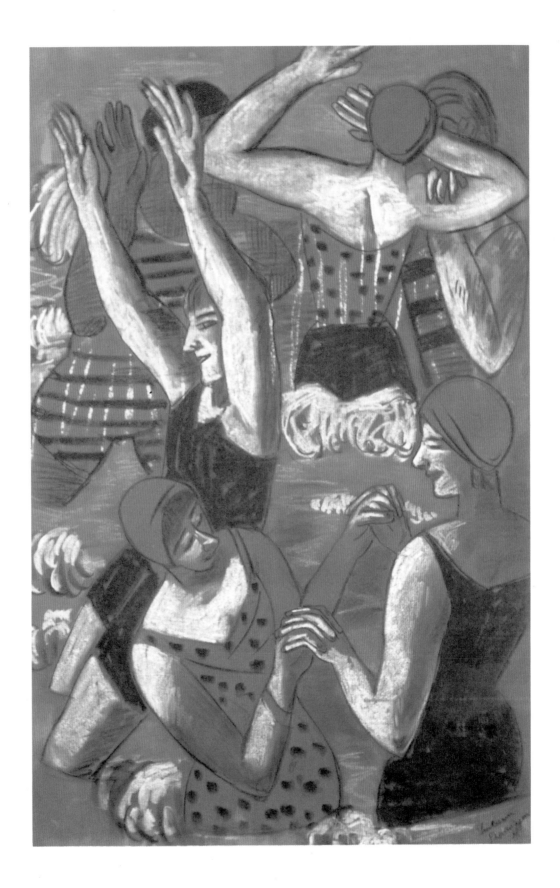

CATALOGUE NO. 88

George Grosz

German, 1893–1959

Der Schuldige bleibt unerkannt (The Guilty One Remains Unknown)
1919

Pen and brush with black ink and collage on cream laid paper
507 × 355 mm (20¹⁄₁₆ × 14 in.)

Inscribed: recto, in pencil, lower right, *Grosz*; lower left, *Der Schuldige bleibt unerkannt*; verso, lower right, in blue crayon: *Grosz/1919/Berlin*

Gift of Mr. and Mrs. Stanley M. Freehling, 1964.236

ONE of the leading satirical draftsmen of the early twentieth century, George Grosz had a violent dislike of authority and, in particular, of the bourgeoisie, who are the butts in many of his biting pen drawings. Following his studies in Dresden, Grosz joined the army but was court-martialed and nearly shot for insubordination. In 1918 he helped to found the Dada movement in Berlin. Intended to shock and outrage, Dada grew out of the feeling of numbness and senselessness engendered by World War I. *Der Schuldige bleibt unerkannt* is one of a number of collages that Grosz made in 1919 and 1920, when he was most involved with the Dadaists. In these works he pasted small clippings from newspapers and magazines onto black pen drawings. Here the violent, grotesque portrayal of a man and a woman is enmeshed in a complicated grid of seemingly un-related images. The ambiguity of the title, which may be understood either as "The Guily One Remains Unknown" or "The Guilty One Remains Unrecognized," probably appealed to the artist.

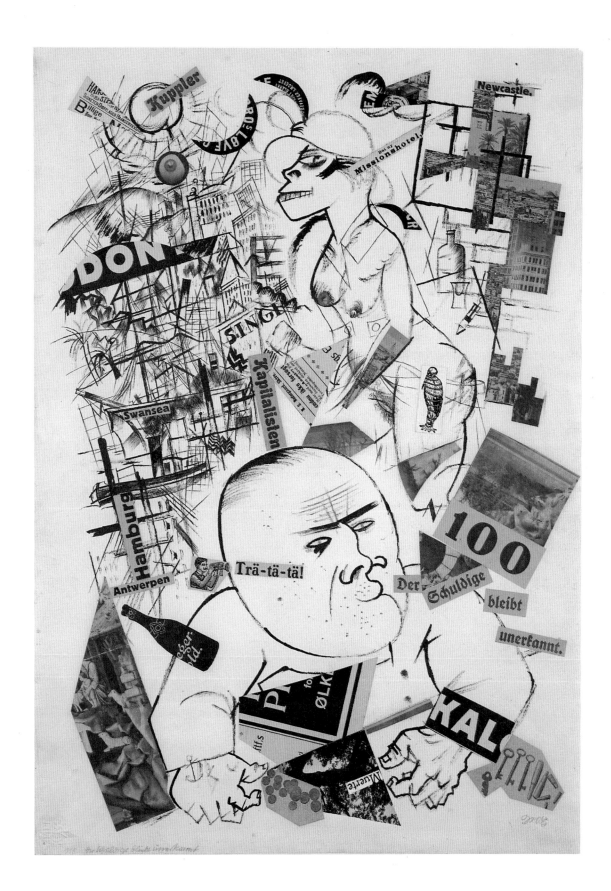

CATALOGUE NO. 89

Gustav Klimt

Austrian, 1862–1918

Reclining Girl
c. 1912/14

Blue pencil on cream simili Japan paper
355 × 563 mm (14 × 22¼ in.)
Inscribed recto, lower right, in blue pencil: GUSTAV/KLIMT
Wentworth Greene Field Fund, 1967.142

COFOUNDER of the Austrian Secessionist movement, Gustav
Klimt was the foremost painter of the Jugendstil in Vienna. He
was principally a decorator, known for his murals and mosaics, but
he was also a draftsman of great elegance and originality. This
sensual study of a reclining woman is made of long, sinuous lines in
blue pencil which twist back upon themselves in an erratic, yet
graceful fashion. The economy of means and almost casual pose of
the model are typical of Klimt's freest, most spontaneous style, and
therefore help to date the sheet in the years 1912 to 1914.

194

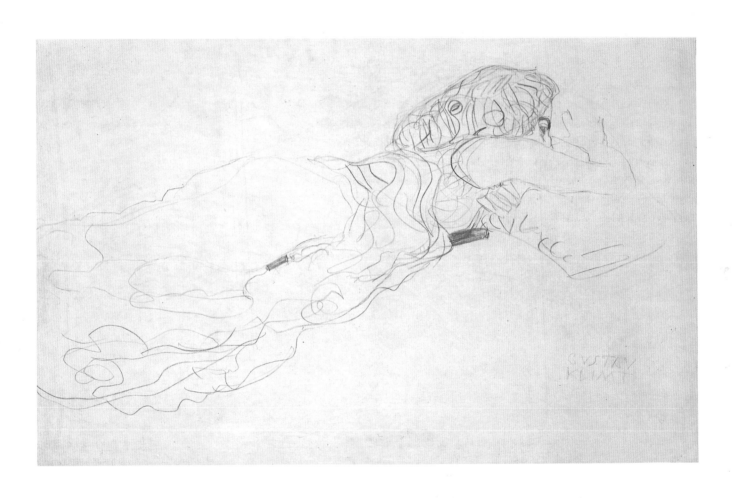

CATALOGUE NO. 90

Oskar Kokoschka

Austrian, 1886–1980

Portrait of Alma Mahler
1913

Charcoal on ivory wove paper
497 × 340 mm (19¼ × 13⁷⁄₁₆ in.)
Inscribed recto, lower left, in charcoal: *17.V1.13/OK*
Anonymous gift in honor of Dr. John Gedo, 1979.120

ALTHOUGH influenced by the Brücke group and fellow Viennese artist Gustav Klimt (cat. no. 90), Oskar Kokoschka was essentially self-taught; he arrived in Vienna at the age of eighteen and soon developed a highly individual Expressionist style. His early portraits in particular are filled with a restless energy and psychological tension. This penetrating drawing of his lover Alma Mahler—young widow of the composer—focuses as much on the spirit of the sitter as on her outward appearance. We know from other portraits he made of her that Alma Mahler was a beautiful socialite of about thirty (he was twenty-five when they met in 1911). Yet here, her disheveled, mature, almost hawkish countenance gives no hint of the youthful charm for which she was known. Instead the portrait reflects the melancholy feeling of doom that Kokoschka felt was always present during their turbulent and unstable relationship of nearly four years. The vigorous working of the charcoal, as well as the intensity of his vision, expresses the artist's powerful, if ambivalent, feelings for his model.

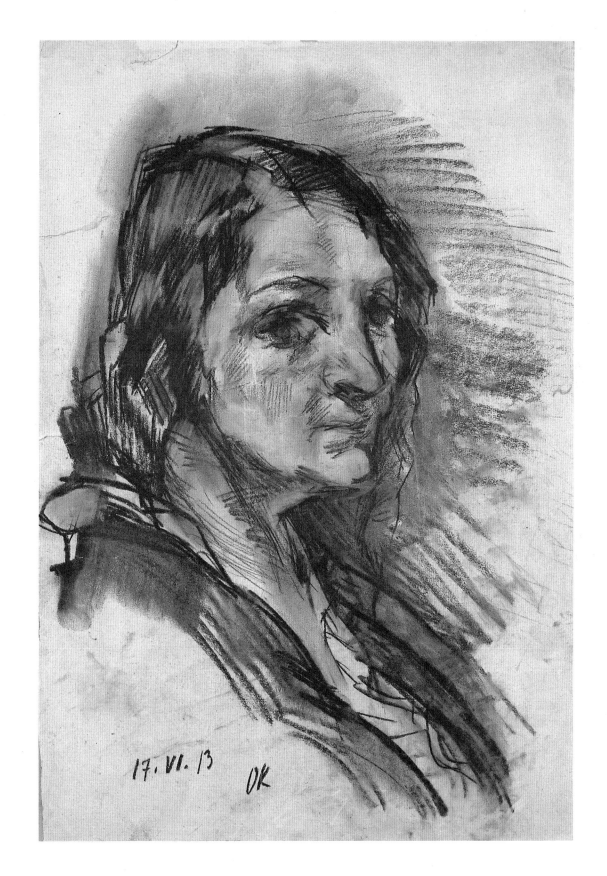

CATALOGUE NO. 91

Egon Schiele

Austrian, 1890–1918

Russian Prisoner of War (recto)

1916

Pencil and gouache on ivory wove paper

438 × 308 mm (17⁵⁄₁₆ × 12³⁄₁₆ in.)

Inscribed: recto, mid-right in a box, in pencil, EGON SCHIELE/*1916*; upper right, in pencil, by Grigory Kladzhishvili in Cyrillic alphabet, *Grigory Kladzhishvili*; verso, mid-right, in pencil, EGON SCHIELE/*1913*

Gift of Dr. Eugene Solow in memory of Gloria Blackstone Solow, 1966.172

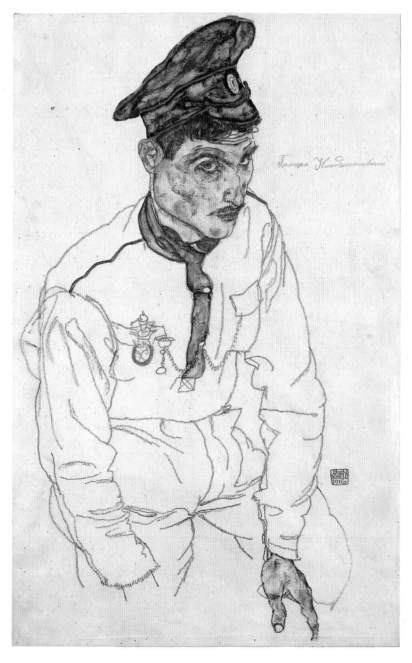

A contemporary of Oskar Kokoschka, Egon Schiele, too, was influenced by Gustav Klimt and the Secessionists (cat. no. 90). A draftsman of exceptional energy, Schiele left more than a thousand drawings at the time of his early death as a victim of the influenza epidemic of 1918. Some of the best examples of his unique Expressionist style are to be found among the many portraits he made under the influence of the new Freudian psychology.

The striking portrait entitled *Russian Prisoner of War* was produced in 1916, when Schiele—who had been inducted into the army in 1915—was posted in Mühling at a prison camp for Russian officers. There, with a studio at his disposal, he produced a series of haunting portraits of his prisoner-charges. In this drawing, Schiele focused on the tense, suspicious face of the Russian officer; yet, with a few simple lines, he also captured the exhaustion of the man's body. One senses fear and desolation simultaneously. Perhaps in a gesture of friendship, Schiele had the sitter, Grigory Kladzhishvili, sign his portrait.

Couple (Self-Portrait with Wife) (verso)
1913

Pencil on ivory wove paper

This sheet is noteworthy also for a drawing on the verso, which is signed and dated by the artist. It is a pencil sketch of Schiele and his wife, seen nude and in three-quarter length. Although clearly a rapid study, the line quality is sure and expressive; the image is the purest example of the anxious eroticism that made Schiele's work so controversial in his day and so moving in ours.

VERSO

Theo van Doesburg

Dutch, 1883–1931

Man at Coffee Table

1916

Pen and black ink over pencil, heightened with white gouache, on buff wove paper

340 × 216 mm (13⁷⁄₁₆ × 8³⁄₁₆ in.)

Inscribed recto, lower right, in pencil: *Theo v. Doesburg 16–*

Gift of Miss Margaret Fisher, 1982.114

THEO van Doesburg founded the movement known as De Stijl, as well as the magazine of that title, in 1917. In early issues of the magazine Piet Mondrian supported van Doesburg in advocating abstraction and simplification in art. The artists who followed van Doesburg and Mondrian sought to eliminate everything lacking clarity and order; the new style relied on rectangles and architectonic forms. Ultimately these ideas were fundamental to the development of such avant-garde movements as that represented by the Bauhaus. This drawing illustrates the important principles of De Stijl a full year before the artist publicized them in print. Despite its intimate scale and subtle execution, its insistence on the clear abstraction of form makes it a historically significant work.

CATALOGUE NO. 93

Pablo Picasso

Spanish, 1881–1973

Head of a Woman
1909

Watercolor and gouache on cream laid paper
306 × 233 mm (12⅛ × 9¼ in.)
Inscribed recto, lower left, in pencil: *Picasso/09*
Gift of Mr. and Mrs. Roy J. Friedman, 1964.215

PABLO Picasso significantly and continuously influenced the evolution of modern art throughout the course of a career that spanned seven decades of the twentieth century. The major force behind the development of Cubism, Picasso used drawing in his Analytic Cubist period (c. 1907–14) to crystallize his ideas about painting. These drawings usually are "painted" in wet media such as watercolor, gouache, or ink. *Head of a Woman*, a watercolor and gouache of small scale, probably was made in Paris in the winter of 1909. Because of its strong resemblance to other portraits he made of her at this time, the drawing is thought to represent Picasso's lover Fernande Olivier. The artist manipulated her countenance to suit his Cubist vision, hollowing out the sockets of her eyes and chiseling the planes of her face into small facets. The sculptural construction of the head and upper body is based entirely on strong diagonal brushstrokes that provide a scaffolding for a gentler watercolor wash.

CATALOGUE NO. 94

Pablo Picasso

Nessus and Deianira
1920

Silverpoint on paper prepared with a white ground
213 × 270 mm (8⁷⁄₁₆ × 10¹¹⁄₁₆ in.)
Inscribed recto, upper left, in black ink: *22-9-20/Picasso*
Clarence Buckingham Collection, 1965.783

PICASSO'S first use of a specific subject from classical mythology occurred in Juan-les-Pins between September 11 and September 22, 1920, when he made a series of six drawings based on the Greek legend of Nessus and Deianira. Recounted in the ninth book of Ovid's *Metamorphoses*, the story centers on the abduction of Hercules's bride, Deianira, by the centaur Nessus, who had promised to ferry her across a river. In this small silverpoint, the penultimate drawing in the series of six, we see the climax of the story, when the struggling woman is about to be ravished by her leering abductor. A dramatic portrayal of rape, lust, fear, and resistance, Picasso's drawing is nevertheless a beautifully balanced and carefully posed composition that often has been likened to the Parthenon metopes depicting confrontations of Lapiths and centaurs. Also harking back to an earlier artistic tradition is Picasso's use of silverpoint, a medium used extensively in the Renaissance. In this drawing Picasso, a consummate draftsman, was undaunted by the irreversible character of his medium; the image is set down with extraordinary confidence and clarity.

CATALOGUE NO. 95

Pablo Picasso

The Embrace of the Minotaur
1933

Pen and black ink with brush and gray wash on blue wove paper

480 × 630 mm (19 × 24⅞ in.)

Inscribed recto, in ink: lower right, *Picasso*; lower left, *24 juin XXXIII Boisgeloup*

Margaret Day Blake Collection, 1967.516

Minotaur and Wounded Horse
1935

Pen and black ink with colored chalk on ivory wove paper

340 × 514 mm (13⁷⁄₁₆ × 20⁵⁄₁₆ in.)

Inscribed recto, in pencil, upper right: *Boisgeloup— 17 Avril XXXV*; lower right, *Picasso*

Anonymous Promised Gift

I N the spring of 1933 Picasso produced a group of etchings, later published as the *Vollard Suite*, on another subject from Greek mythology (see cat. no. 95), the Minotaur. A monstrous creature with a bull's head and a man's body, the Minotaur became a frequent theme in Picasso's drawings of the period as well. Here we see an interpretation that distinctly recalls the Nessus and Deianira series of thirteen years earlier. A struggling nude woman is enveloped in the powerful embrace of the beast, their limbs entangled. Picasso's handling of the medium is a parallel to the Minotaur's attack: the brushstrokes are full of barely controlled excitement; the thin layers of wash add an element of mystery and sensuality. The Minotaur was a complex symbol for Picasso, at once representative of the untamed sexuality of man and, yet, also a tragic hybrid torn between his human and animal needs. It is perhaps this unresolved tension that continued to fascinate Picasso as he explored the subject.

In another splendid drawing, dating from the spring of 1935, Picasso again took up the theme of the Minotaur, this time pairing it with another of his artistic preoccupations, the wounded horse. Their confrontation is set in a bullring, with a crowd of spectators suggested in the background. The drawing is clearly related in spirit to a series of paintings and drawings that Picasso had devoted to episodes of the corrida during the previous summer. Here the bull has been replaced by the Minotaur, investing the battle between the two beasts with an unsettling human element. The gored horse, with its magnificent head and neck thrown up to the sky, is as masterful a characterization of an animal's primal fear and agony as anything produced by Eugène Delacroix or Peter Paul Rubens. Picasso's versatility as a draftsman is nowhere more apparent than in the varied handling of the sheet, which ranges from the bold colorful sweep of the chalk to the decorative, playful pen line that describes the body of the horse. The muscular Minotaur is rendered in precise, tightly worked hatchings that help to make him the focal point of the composition.

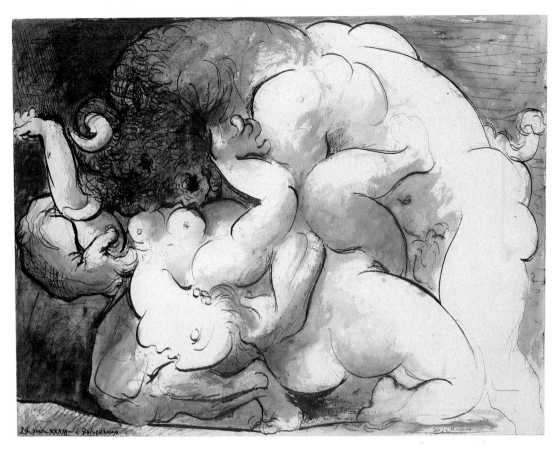

CATALOGUE NO. 96

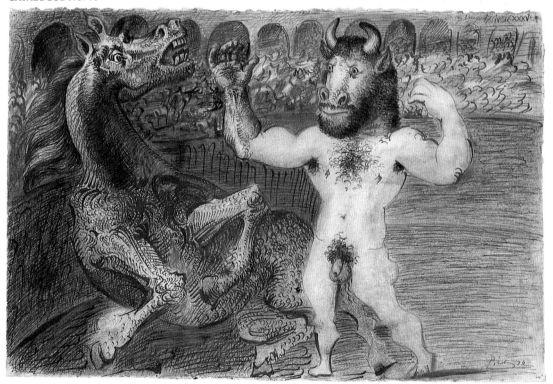

CATALOGUE NO. 97

Joan Miró

Spanish, 1893–1935

The Kerosene Lamp
1924

Black and white chalk with touches of pastel and red pencil on canvas
810 × 1003 mm (32 × 39⅝ in.)

Inscribed: recto, lower center, in blue ink, *Miró 1924*; verso, in black paint, *Joan Miró/"La Lampe a Petrole"/1924*

Joseph and Helen Regenstein Foundation, Helen L. Kellogg Trust, Blum-Kovler Foundation, Major Acquisitions Fund, and Gifts from Mrs. Henry C. Woods, Members of the Committee on Prints and Drawings, and Friends of the Department, 1978.312

A Surrealist painter of Spanish origin, Joan Miró received his early training in Barcelona. In 1919 he went to Paris, where, for a time, he painted simple, realistic forms, often still lifes. However, in 1923/24 a radical shift occurred in his style, and almost overnight he began to fill his canvases with abstract, highly imaginative symbols. Although he abandoned objective representation, Miró never thought of his work as abstract. Nevertheless, the complex and personal nature of his symbolic vocabulary invests his art with a certain degree of mystery.

The Kerosene Lamp, a drawing produced shortly after the dramatic stylistic developments of 1923/24, is related in subject matter to *The Carbide Lamp* (The Museum of Modern Art, New York), a more realistic painting from 1922/23. In both works, the lamp seems to be a feminine symbol; in *The Kerosene Lamp*, the flame is an additional symbol of woman, one that is found in other drawings of this period, such as *The Family* (The Museum of Modern Art, New York). The Art Institute's drawing is a fully elaborated composition on canvas—perhaps originally intended as an underdrawing for a painting, but clearly finished enough to have satisfied the artist in its present state. The dynamic forms that fill the composition are held in check by a discreet geometrical grid, an indication of Miró's sensitivity to the ideas of Cubism and a device found in other of his large-scale drawings of 1924. The understated color scheme has both the strength and subtlety of Miró's gray-ground paintings of the same period.

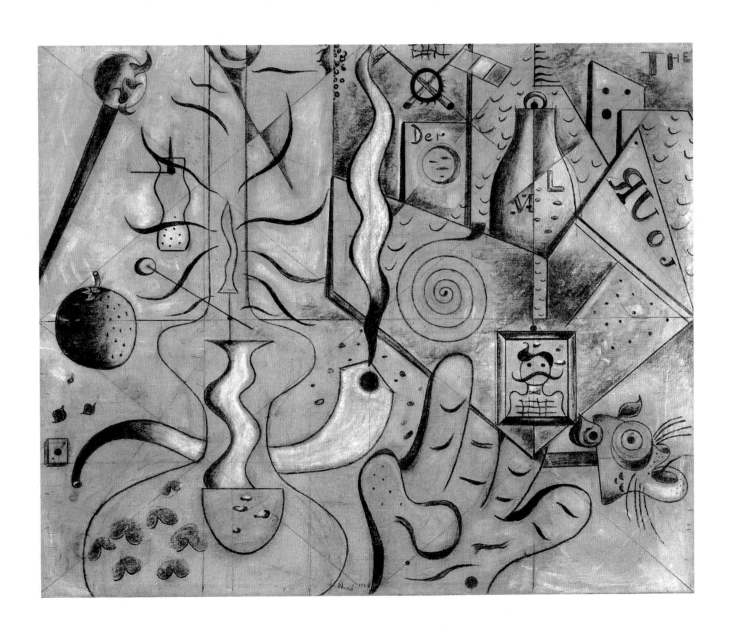

CATALOGUE NO. 98

Salvador Dali

Spanish, born 1904

City of Drawers

1936

Pencil on ivory wove paper

352 × 522 mm (13¹⁵/₁₆ × 20⅝ in.)

Inscribed recto, lower right, in pencil: *Salvador Dali 1"36*

Gift of Frank B. Hubacheck, 1963.3

A Spanish artist who officially joined the Surrealist movement in 1926, Salvador Dali is well known for his bizarre imagery based on the seemingly chance juxtaposition of unrelated objects. Dali's early artistic training took place at the Museo de la Real Academia de Bellas Artes de San Fernando in Madrid, where he was instructed in the classical academic tradition. This training is apparent especially in his drawings, which, no matter how otherworldly, demonstrate a masterful technical facility. A superb example is this *City of Drawers*, one of the earliest studies for the painting entitled *The Anthropomorphic Cabinet* of 1936 (Kunstsammlung Nordrhein-Westfalen, Düsseldorf). Although the vista in the upper right-hand corner is sketchy, the figure is meticulously detailed. The origin of this unusual image, which appears in many paintings and drawings of 1936 and 1937, is not known, although several hypotheses have been suggested. It is possible that while in London in 1936, Dali heard someone refer to a "chest of drawers" and, with his then-minimal understanding of English, took the phrase literally. Another possibility is that he derived the idea from the furniture-figure constructions of Giovanni Battista Bracelli, a seventeenth-century fantasist. For several years in his works of the mid-1930s, Dali was interested in constructing human forms with furniture and, conversely, in building furniture with parts of the human anatomy. This figure, with its upper torso filled with drawers, is one of the artist's favorite variations on this theme.

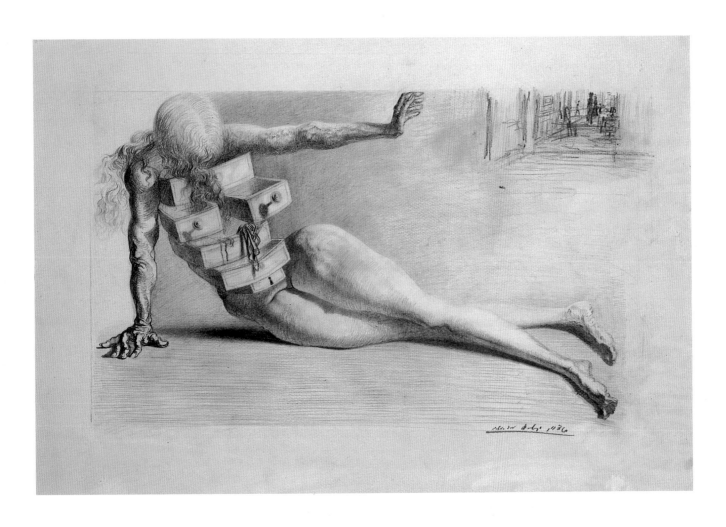

CATALOGUE NO. 99

Arshile Gorky

American, born Armenia, 1904–1948

The Artist's Mother

1926 or 1936

Charcoal on ivory laid paper

630 × 485 mm (24⅞ × 19³⁄₁₆ in.)

Inscribed recto, lower right, in charcoal: *A. Gorky 1936* [26?]

Worcester Sketch Fund, 1965.510

ARSHILE Gorky was born in Turkish Armenia to a peasant family, and the terrible hardships and poverty of his first fifteen years affected him throughout his career. In 1915, under threat of the Turks, the family fled to Caucasian Armenia. Amid brutal massacres and persecution, the family eked out a living, but in 1919 Gorky's mother died of starvation. In the following year, he and a sister immigrated to the United States.

One of the most beloved portrait drawings in the Art Institute collection, this splendid image of Gorky's mother, Lady Shushanik, is based on a photograph of the artist and his mother taken in the province of Van, Armenia, in 1912. The same photograph served as inspiration for two great canvases entitled *The Artist and His Mother* (Whitney Museum of American Art, New York; National Gallery of Art, Washington, D.C.), as well as numerous notebook sketches and drawings. The Art Institute's drawing is the most finished of these sheets. Here one senses clearly the reverence that Gorky had for the memory of his mother. Despite her gauntness and blank stare, the woman appears to have an inner strength equal to the outward monumentality of her form. The large eyes are the most remarkable aspect of this remarkable countenance.

The date in the lower right corner of the sheet has been interpreted variously as 1926 or 1936; either date is plausible, since Gorky was involved in the canvases of *The Artist and His Mother* throughout that decade. It clearly was a theme that compelled him to constant reexamination.

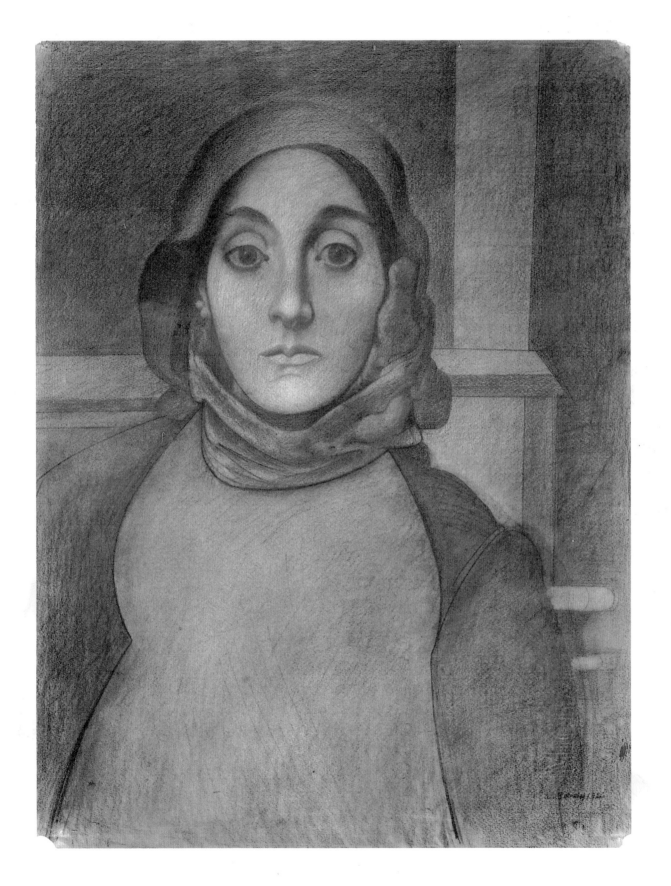

CATALOGUE NO. 100

Arshile Gorky

Untitled

1943

Pencil and colored crayon, with areas of paper scratched away, on ivory wove paper

580 × 735 mm (22¹⁵⁄₁₆ × 29¹⁄₁₆ in.)

Inscribed recto, lower right, in pencil: *A. Gorky/43*

Ada Turnbull Hertle Fund and Gifts of Peter Bensinger, Helen Regenstein, Joseph R. Shapiro, and Louis Silver, 1963.571

GORKY's untitled drawing of 1943 represents an impulse in drawing vastly different from that which motivated the portrait of his mother (cat. no. 100). It is startling that in the course of such a short period of creative activity, Gorky should have worked his way through such a complete stylistic evolution. Far removed from the quiet, formal, almost classical portrait, this sheet is a passionate, aggressively free interaction of abstract forms. In July 1943 Gorky vacationed in the foothills of the Appalachians, at the Virginia farm of his wife's parents. There he devoted most of his time to drawing out of doors. In this lush mid-summer landscape, he developed an imagery based on the natural forms around him. This intense period of observation produced drawings of leaf, seed, and pod shapes. Although motivated by a kind of nervous energy that suggests it was drawn with some passion, the essentially joyous riot of color in this drawing provides little indication of the suffering and despair of Gorky's last years, which eventually caused him to take his own life.

CATALOGUE NO. 101

Jackson Pollock

American, 1912–1956

Untitled

1944

Pen and brush with black and colored ink on ivory wove paper
480 × 632 mm (19 × 25 in.)
Inscribed recto, lower right, in black ink: *Jackson Pollock 44*
Ada Turnbull Hertle Fund and Gifts of Mrs. Leigh B. Block, Margaret Fisher, William Hartmann, and Joseph R. Shapiro, 1966.350

UNTIL his premature death in 1956, Jackson Pollock was the leading exponent of Abstract Expressionism, the style frequently referred to as Action Painting. His working method, which revolutionized contemporary painting, involved pouring and dripping paint onto a canvas laid flat on the floor. Moving around and even on his canvas and controlling the flow of the paint was for him the most natural way to involve himself in his art. Although today Pollock's hallmark is his "action painting," it was not until 1947 that he abandoned the brush completely in favor of the dripping and pouring method. This untitled drawing of 1944 anticipates the artist's breakthrough of three years later, in the raw energy of the composition and the vigor with which the brilliant inks are splattered across the paper.

Pollock drew incessantly, but never made preparatory sketches for paintings. His drawings are always independent entities. That is especially true in the case of this sheet, which is one of the few drawings that he ever signed and dated. An exuberant celebration of method and materials—even of the art of drawing itself—this work exemplifies Pollock's wish to express his feelings rather than merely to illustrate them.

CATALOGUE NO. 102

Jean Dubuffet

French, born 1901

Portrait of Henri Michaux
1947

Black India ink on board, with white areas scratched away (scratchboard)
500 × 315 mm (19¾ × 12½ in.)
Inscribed recto, left, in ink: *HENRI/MICHAUX/J. Dubuffet/47*
Bequest of Grant J. Pick, 1966.348

AT one time a satellite of the Surrealist circle, Jean Dubuffet has always cultivated antiestablishment beliefs with regard to art. Partially through the influence of Paul Klee, he came to admire and use as a source the art of children, psychotics, prisoners, and urban graffitists. Dubuffet preferred the amateur spontaneity of these unusual art forms to professional artistic methods. In 1942 he began using nontraditional materials.

In 1947 Dubuffet produced a series of portraits entitled *More Beautiful than They Believe*, in which he rejected the tradition of portraiture, especially its emphasis on the individuality and recognizability of the sitter. This portrait of the artist's friend Henri Michaux is a work from this series and one of more than ten portraits Dubuffet made of Michaux. A well-known draftsman and poet, Michaux is hardly recognizable here, so distorted are his features. His body, seen frontally, is ungainly and oversimplified in a childlike fashion. All pretense at resemblance has been discarded; instead, a remarkable, almost violent characterization of the man emerges from the heavily scratched background.

CATALOGUE NO. 103

Index

Page numbers printed in *italics* refer to illustrations.

LEARNING RESOURCES

CENTER

ILLINOIS CENTRAL COLLEGE
MCMLXVI

East Peoria, Illinois